WELCOME
TO MY
STUDIO

Books by Helen Van Wyk
Casselwyk Book on Oil Painting
Acrylic Portrait Painting
(out of print)
Successful Color Mixtures
Painting Flowers the Van Wyk Way
Portraits in Oil the Van Wyk Way
Basic Oil Painting the Van Wyk Way
(Revision of Casselwyk Book on Oil Painting)
Your Painting Questions Answered from A to Z
Welcome to My Studio

Adventures in Oil Painting

WELCOME TO MY STUDIO

with

Helen Van Wyk

ART INSTRUCTION ASSOCIATES 2 Briarstone Road, Rockport, MA 01966

WELCOME TO MY STUDIO

Editor: Herbert Rogoff
Design: Herbert Rogoff
Production: Cathy Gale
Photography: Clark Linehan

Copyright© 1989 by Helen Van Wyk
All rights reserved
Published by Art Instruction Associates
2 Briarstone Road
Rockport, MA 01966

Printed and bound in the United States of America

ISBN 0-929552-05-9

Contents

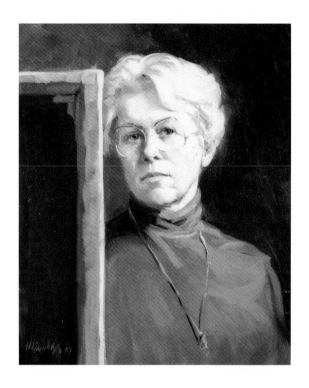

HELEN VAN WYK BY HELEN VAN WYK

When people view one of my self portraits, they always say "It looks like you but it's too serious." I explain that my self portraits record, as I paint, the expression that I see in the mirror, which is one of concentration and study, not the one they know; I could never paint the expression they see. This elementary fact can help define a painting's originality and explain how it is one of a kind, a factor that justifies its value. A painting, in this case my self portrait, is a reaction to *what I see* and *how I feel* about what I see at the time I'm at the easel. I could never capture that same experience again. Why would I want to? And even if I tried, it couldn't be the same because there would be a memory and a reaction to that past experience. Here's one of my many philosophies: "You can't repeat past success; the pressure is too inhibiting." The fact that I feel my paintings never turn out the way I really want them to do, never discourages me. Instead of *"measuring up,"* I have the advantage of starting a new painting with the determination to *try again* and say, "Okay, *this* time...."

Paintings by Helen Van Wyk

Paintings by Helen Van Wyk

Introduction

Anyone can paint. Mainly, you have to want to. You don't even have to learn to do so; you just need the necessary materials and an eagerness to try. By painting your first picture you come to the conclusion that there is much you need to know in order to paint better. Some wise person once said, "Painting is easy. Painting well is impossible."

The chapters in this book are devoted to basic principles, techniques and procedures that will help you gain the insight to develop your painting abilities so much that you may even earn the title of "a talented artist."

I studied with M.A. Rasko. Even though that was many years ago, I can still hear his Hungarian-accented voice intone: "The painting principles of the **two-dimensional surface expression** (Rasko's definition for painting) take up sixteen pages — no more, no less."

It is true that **there are only seven components** that make up the painting process, and sixteen pages can easily define them. I find them so fascinating and so far-reaching—and I love to teach — that I have expanded Mr. Rasko's sixteen pages in this book and the five previous ones that I've written. Why, you may ask, have I written another book? This one is different. Its uniqueness comes from years of teaching experience. I came up with the idea that a good way to learn more about painting is not only by reading but by having a tour through an artist's studio. **Welcome to My Studio's** chapters are my studio's walls and easel, with me as your guide to acquaint you with the important factors that will enable you to paint better, if you are already painting, or to encourage you to try.

I hope that this book, along with joyful hours in front of an easel, will add an intriguing dimension to how this world looks to you.

Helen Van Wyk
Rockport, Mass.

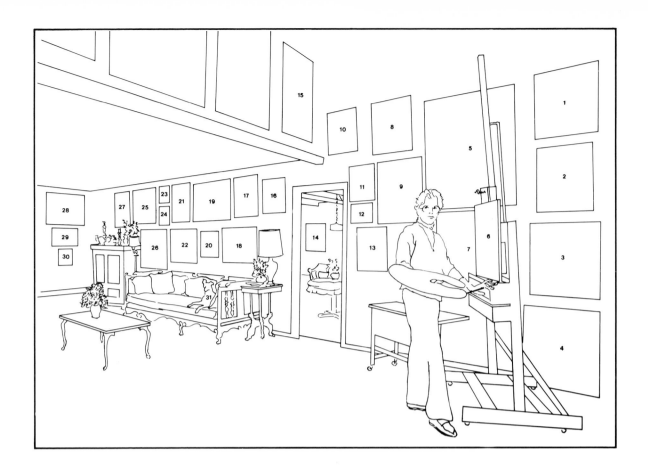

About the cover

The diagram identifies the paintings that are pictured on the cover. The thirty paintings represent only one-fifth of the total paintings that hang in our house. We have a lovely collection of watercolors, many by Rockport artists, some charming miniatures and a captivating portrait of a woman that was painted by John Singer Sargent, which, unfortunately, is not shown; it hangs on another wall.

1 Melissa. **2** A portrait sketch of Herb's Uncle Morris, done at a summer demonstration. **3** Jimmy. **4** Trastevere, Rome. **5** Herb. **6** A portrait sketch of Cathy Gale, painted at a demonstration at the Rockport Art Association. **7** A self portrait that I painted in 1984 for my book, "Portraits in Oil the Van Wyk Way." **8** Bonita Valien. **9** Another self portrait, for the magazine "Palette Talk." **10** Jay, Herb's son, as I saw him in 1986. **11** Italy. **12** Herb, as he looks on Sunday mornings. **13** Little Anna. **14** Brittany's portrait is seen hanging in the gallery. **15** Paolo Pansa, a dear, old friend. **16** An apostle, painted by M.A. Rasko. **17** St. Francis, another painting by Rasko. **18** Herb. **19** A view of Castelgandolfo, Italy, which I painted in 1958. **20** A Dutch landscape, circa 1800. **21** A painting of me by Rasko, 1956. **22** Trevi Fountain, painted by an Italian artist in 1854. **23** A little landscape of rowboats by Jim Fitzgerald. **24** Roman Monk. **25** Central Park. **26** A watercolor by Joseph Santoro. **27** A still life I painted when I was 19 years old. **28** A clipper ship by Charles Vickery. **29** Cape Ann surf as interpreted by Charles Vickery. **30** A *trompe l'oeil* of a Della Robbia bas relief. **31** Flash, our dear little black whippet. Gioia, our other whippet, was camera shy.

Materials

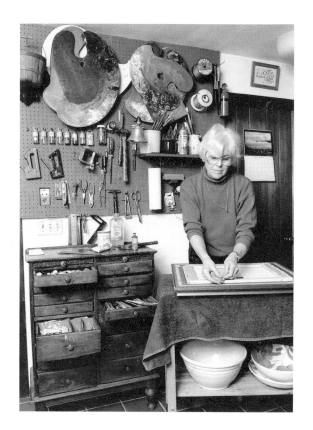

I do not have to teach self expression. You will do that automatically.

I do not have to teach the emotional experience of painting. The joys and frustrations of painting are going to happen regardless of what I say. **I can't even teach the art of painting or a personal touch.** I am limited to teaching the craftsmanship of painting. So, the best way to start is to acquaint you with painting supplies. Yours do not have to be elaborate, just adequate, and–just as important—well organized. It is a myth that all artists are messy. Just take a look at the cover. Yes, that's my studio; that's where I paint.

You'll need the following:

A studio Just a place to paint where the lighting makes painting as easy as possible.

Black and white paint To help you paint the tone values of your colors.

A palette To hold and mix your colors.

Brushes To apply the paint to the canvas in shapes.

Oil Colors A wide enough selection of colors to mix the colors of nature.

Turpentine To thin the paint in the beginning stages and to clean your brushes.

Linseed Oil To mix with turpentine for some paint applications.

A rag To regulate the paint on your brush as you work.

An easel To hold your canvas.

A canvas A surface to work on.

Damar Varnish To apply to finished paintings to show off the colors' true beauty.

I keep my painting equipment in a utility room that adjoins my studio. The lovely antique cabinet holds my paints and brushes and you can see my tools and palettes hanging on the peg board.

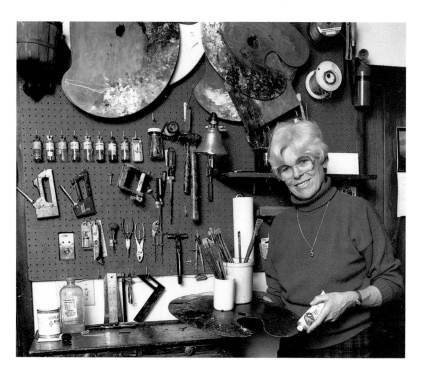

and now... come into my studio

My studio

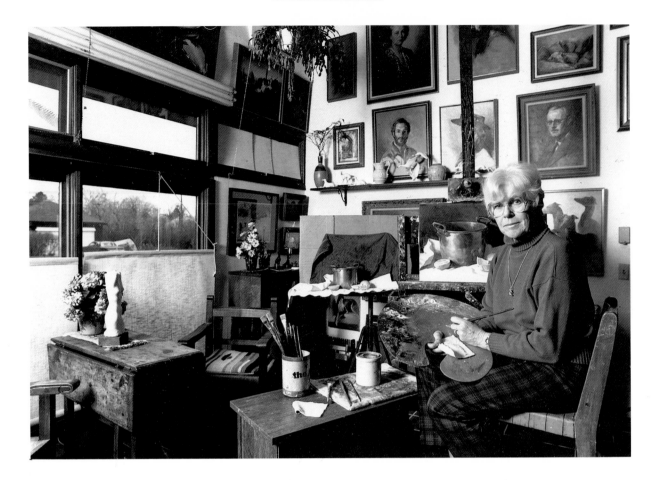

Now I'm in my studio, about ten feet from the utility room (you can consolidate this elaborate arrangement into a well-stocked paint box and a corner of a room). No matter **how you arrange your studio,** it should have these essentials:

1. **One source of light** that causes contrast of tone on a subject. (Notice the lights and darks on the still life setup.) This lighting can be just a spotlight shining on a subject rather than natural light. Light from a northern window is ideal because it's the one that changes the least during the day. I once had a studio with a west window; I had to stop painting as soon as the sun streamed in.

2. **A sturdy, adjustable easel** that holds your painting upright.

3. **A taboret,** or place for your brushes, turpentine and palette, when you don't need to hold it.

4. A subject that's seen easily from your painting position in the lighting condition that enables you to see contrasts of tone.

Notice how the light is coming from the left, shining on the subject, and my point of view is from the right of the subject, where I can best see the shadows.

You can see by the lighting in many of my paintings that I paint in this position often. The paintings where the lighting comes from the right were done when I set up facing the opposite wall in the studio, the one that's shown on the cover.

You can see in the photograph that I control the lighting on my subjects by shading the windows of my studio. The antique table by the window is my favorite "writing place." On it is a nude statue by Domenico Facci. Behind the still life setup is an antique desk. The portrait of the bearded man is Herb's son (a more recent one of him appears on the cover, above the door to my gallery), and above that is a portrait of my mother that was painted by M.A. Rasko.

I usually stand when I paint so I can constantly step back to view my progress. Now and then, when I work on an involved area, I paint sitting down. I use a sculptor's stand for my still life subjects. Since it moves up and down, I can regulate its height to choose a point of view of my subject, from looking down at it to almost eye level.

Brushes: Start with a broom, finish with a needle

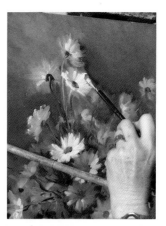

Just as a carpenter has a variety of tools that enables him to do his work, the artist has to have a variety of brushes; they are the precious tools of his craft. Using a brush that is the most suitable for each job is the best economy measure as well as the most efficient way of working. **Don't try to make one brush a jack-of-all-trades.**

It's a pity that brushes wear down from the constant friction that the roughness of the canvas causes. The life of a brush can be lengthened by using enough paint; **do not try to spread a little a long way.** Of course, you will use more paint but by doing so you will be imparting a look that is so much better than one of a paint-starved canvas.

BASIC JOBS AND BRUSHES FOR THEM

1. For sketching in the placement, composition and structure. Yes, do this with a brush not a pencil or charcoal. Use a size 3 bristle filbert. If the marks look wrong to you, you can easily remove them with a turpentine-soaked rag and start over.

2. For massing in large areas, such as backgrounds and big areas of light and dark tones. One size 12 bristle Bright and one size 10 bristle filbert.

3. For the development of the painting, a variety of medium-sized bristle brushes, sizes 6 through 10.

4. For cutting in shapes and fusing tones at the more developed stages, a variety of medium-sized red sable or sable-type soft brushes.

5. For the finer details, some smaller red sables or sable-type soft brushes.

6. For blending or dusting away paint or for dragging over painted areas, a large, soft brush, such as the Japanese Hake brush.

7. For signing your name, a small red sable.

I use Grumbacher brushes: Red sables, sabelines, white bristles and the synthetic Bristlettes.

My palette and colors

Because I'm lefthanded. I had the picture of my palette flopped so I could explain the arrangement of the colors from left to right:

Superba White	The lightening agent for colors. Any white will do, as long as the consistency is soft and buttery.	**Burnt Umber** **Burnt Sienna** **Indian Red**	Even darker, duller versions of yellow, orange, red
Thalo Yellow Green **Cadmium Yellow Light** **Cadmium Yellow Medium** **Cadmium Orange** **Cadmium Red Light** **Grumbacher Red**	The yellows, oranges and red colors of the spectrum in light, bright versions used when you see brightly colored things	**Thalo Red Rose** **Alizarin Crimson** **Thalo Blue** **Thalo Green** **Sap Green**	These colors, in admixture with black and white, will make a complete range of tones and intensities of the cool colors — violet, blue and green
Yellow Ochre **Raw Sienna** **Light Red**	Dark, duller versions of the warm colors. These earth colors are necessary to record the more earthy warm colors.	**Ivory Black**	The darkening agent for already dark colors. To be used with white to make tones of gray

The palette is your deciding place where you judge the colors you want to add to your canvas by deciding **the tone, the intensity and the hue** of the color. It's also where you decide on the **thickness or thinness** of application and how much paint you want to load onto your brush. By the time your brush finally gets to your canvas, the only thing it should have to make is the right shape.

A palette should be light in weight and a medium-toned color is best for color mixing. My palettes are very precious. I have quite a few, all fashioned after the one my father made for me when I was eighteen years old and which I still use. It's made of one-eighth-inch mahogany plywood. After every painting session, I religiously clean the mixing area, leaving my lineup of colors intact. My palette fits into a box that I store in the refrigerator in the "Rasko Studio," the one I teach in. I have had copies of this palette manufactured to my specifications and sell it to those who are interested.

From lighting to subject to palette to painting

The **light** makes the subject look the way it does in color and tone; the palette is where the toned color is mixed and judged; the painting that results can be 1) a poor victim of the process, 2) a worthwhile attempt, 3) a beautiful interpretation. **Successful results** depend very much on **successful color mixing.** Let's examine the phenomenon of color and understand it enough to emulate it with paint: 1. We see one natural source of light—the sun. 2. Light is colored; a rainbow proves this. 3. Light shines in a straight line; light and shade proves this. 4. Color mixtures can only substitute for the effect of the light we see. **We make our paint do to the canvas what the light does to the subject.** 5. Where we see colors in light we mix colors into white — a paint substitute for light; where we see colors shaded, we can mix colors into shaded white, a gray made by mixing white and black. *This is a greatly over-simplified analysis of color mixing but it makes a good starting point. Simple beginnings are a way to more profound understandings.* 6. Light is made of the three primary colors: yellow, red and blue (the painter's version of light's magenta, yellow and cyan). If this light (made up of three colors) shines on a subject, **we must use three colors** to record it. Hence, the complementary color theory: using green (mixture of blue and yellow) when painting red things — and vice versa; using violet (mixture of red and blue) when we paint yellow things; and

using orange (mixture of red and yellow) when painting blue things. In this way, we use the three colors of light because a **color and its complement totals three primary colors** (two of them are mixed together). 7. Two primary colors mixed make the secondary colors (violet, green and orange). **Now we have the six colors of the rainbow:** the warm ones — yellow, orange, red, and the cool ones — violet, blue and green. 8. The warm colors and cool colors are complementary to each other. By balancing a warm color with its cool complements we get a grayed effect that records the phenomenon of lighting with paint.

A palette of colors should have paints that will enable you to mix the three properties of color:

Hue. The color and its tendency toward warm or cool color, for example — a yellow can be greenish (cool) or orangey (warm).

Tone. The value of color from almost white to very dark. Yellow can be light like a lemon or dark like brown.

Intensity. The degree of brightness or dullness of a color. Yellow can be bright as the sun or dull as dried grass.

It is true that I could emulate a version of nature's color with only the three primary colors and white, but I want to have a wider variety of versions of color interpretation.

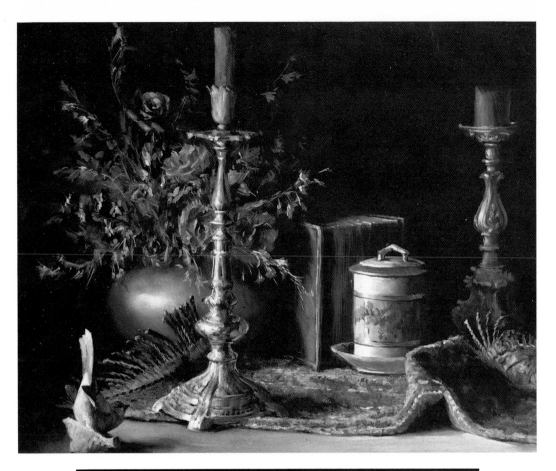

The 7 Components of Pictorial Expression

With your very first painting, you will encounter and use the **seven components of pictorial expression.** They are:

1. **Motivation.** The desire to set down a pictorial version of an idea, a visual experience or inspiration.
2. **Composition.** The organization of your motivation within the confines of a flat surface.
3. **Tone.** Five distinctive contrasting tones that are caused by our nature's lighting condition.
4. **Color.** The mixtures of colored paint that emulate the presence of color.
5. **Rhythm of application.** The actual presence and look of the paint.
6. **Shapes.** The results of perspective, proportion and anatomy.
7. **Lines.** The result of contrasting tones meeting.

Much can be learned about each of these seven components, and can benefit your pictures greatly. For instance:

Compositions are better if they have a well-defined focal area—only one. This is the area or a subject that formulates your inspiration. This area should never be in the middle of the canvas or too close to the edge of the canvas either. The focal point and its supporting composition should be balanced, unified and have variety. Why?

Because we are uncomfortable with the opposite of these characteristics: unbalanced, disconnected and bored by repetition.

By recording the five tone values your subject will look three-dimensional on the flat surface, thus looking natural or, as we say, realistic.

By understanding nature's color you will be able to paint things *as you see them* in various beautiful lighting conditions instead of trying to paint the colors you think they are or remember them to be.

By being **in love** with the endless ways paint can look, you will add style to its **rhythm of application.**

Your **shapes** will improve by realizing how important perspective is (space relationship) proportion is (size relationship) and anatomy is (the structure of things). Your shapes will also improve if you learn that a **line** in paint is not like a line made with a pencil. In paint, it is an edge between two abutting tones. It can be sharp or fuzzy in character and this will stop shapes from looking pasted on.

The seven components are easy to understand and a challenge to orchestrate. Don't think of them as rules, they are opportunities. This book will alert you to using them for more realistic painting experiences.

1. Making the subject fit the canvas

The first step in getting a good composition

The next time you go to an art museum, pay attention to only one factor in every Old Master painting you look at: How the subject has been fit on the canvas. You will find that in every case this compositional factor is so "picture perfect" that you take it for granted.

Successful placement of the subject is not accidental; it is carefully planned out. This chapter is designed to draw your artistic attention to placement and to show you how to situate your subjects nicely on your canvas.

The Portrait
An obvious asset of a portrait often goes unseen; that, of course, is the appropriate placing and size of the subject on the canvas. It doesn't seem too big, doesn't seem too small, doesn't seem too far to the left or too far to the right.

In portraiture, the placement and proportion of the subject contribute to the person's likeness. Because of this, consideration has to be taken to make the pose and the placement describe the character of the model. There are some simple guidelines that I can show you in this chapter to help you deal with this pictorial problem.

A Still Life
A still life is usually an arrangement of varied objects. Sometimes this arrangement makes a nice small picture and sometimes you feel you'll like a larger painting. No matter what size you choose, however, you *always* have the problem of making the composition fit on the size canvas that you've chosen.

I think most people have trouble with the all-important placement stage of the composition because they put more importance on the drawing of each element of arrangement than on the placement of them in relation to each other.

Actually, the drawing stage should be saved for the time when you are secure that you can draw the subject within the placement. Granted, drawing is difficult, so why try to draw and place at the same time? Proportion is an important element in recording what you see. The size relationship of one thing to another is a major part of the placement stage; it is the key to the beginning of the all-important placement and sizing of a subject on a canvas.

The placement of the subject on the canvas is the result of two considerations:
1. How big to make the subject on the size canvas you have.
2. The size relationship of each element of the composition to each other.

This chapter shows you how to deal with these two factors successfully to initiate a well-composed picture.

A Landscape

The placement of the great outdoors on your canvas has to be approached differently from that of portrait and still life.

In landscape painting, you have to single out an area rather than arrange a pose or set up a still life subject. This area, of course, is what attracts you and is called the *focal point*. Again, proportion is the primary consideration. You'll have to set down your focal point, or area, on the canvas in a size that you think will fit as well as allow you to include supportive surroundings. So, again, it is a matter of making the subject fit well on the canvas.

From pose to painting

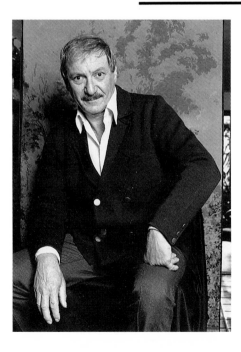 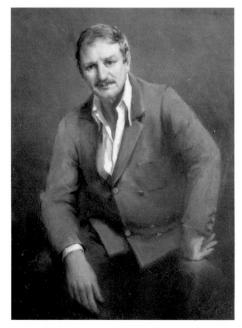

This painting of my husband Herb was inspired by a composition that John Singer Sargent used when he painted his teacher Carolus-Duran. I painted it to have a sample of a large portrait and also to have the joy of painting a portrait without the pressure of commission. The blankness of the white canvas in relation to the magnitude of the subject is so different that a simple beginning is hard to find. Don't let thoughts of a likeness, skin color or even drawing obscure what surely must be your primary concern. Ask yourself, **"How much of the pose do I want to include** from top to bottom and from side to side? And **how can I make it fit on my canvas?"** By solving this initial problem, you'll never have to make the excuse: "My canvas was too small" or "My canvas was too big."

How to fit the pose on the canvas

I make four simple marks with black paint thinned with lots of turpentine to proportion the subject to any size canvas: One for the top of the head, one to show where the bottom of the hand will be, and one on each side of the canvas for the two elbows. Now I actually connect these four marks. I call this shape the **"envelope"** that encases the subject on the canvas, looking to see if its shape corresponds with my model's overall shape. How simple this is to do; you can see what an important contribution it makes. **Correct proportions are a must of good drawing,** so before I begin the drawing stage I determine the size of the head in relation to the entire pose from top to bottom, finding that it is one-quarter the entire size.

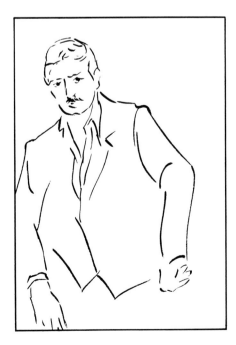

Don't try to place the subject and draw the subject at the same time. You can't do two important things at once

Here is an example of what could happen if you draw the subject without a preliminary placement and proportion stage.

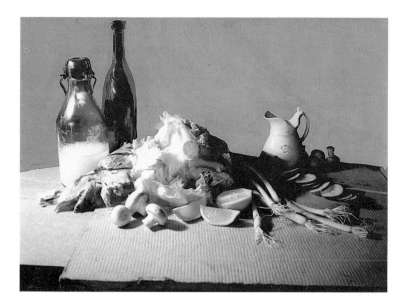

My starting technique is always the same. To place this typical still life arrangement, I wouldn't start with the bottle or the lettuce. Nor would I start with the table line. Instead, I consider the **shape of the entire periphery,** from the top of the bottle to the handle of the pitcher to the end of the scallion to the bottom of the mushroom to the left side of the milk bottle and back to the top of the bottle.

Placing a still life arrangement

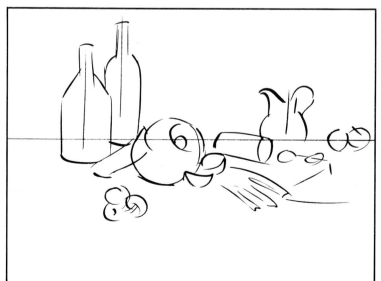

Don't start with the bottle

Drawing the bottle without thinking of the entire arrangement may make it so big that the rest of the objects wouldn't fit.

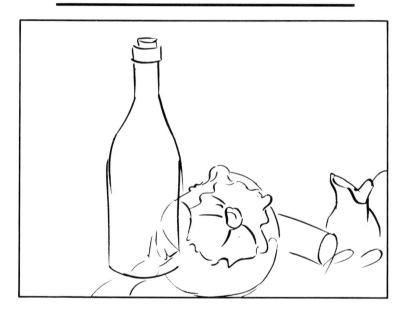

Don't start with the table line

Starting with the table line can lead you to make everything too high.

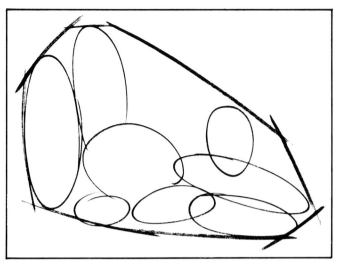

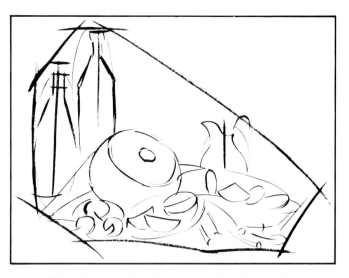

Start with the arrangement

The marks show my "envelope," the reliable shape I use to start my compositions. You must search for a **simple beginning!**

Then I make indications of the size of each element of the entire composition to **make them all fit** within the confines of my overall shape. Save your precious drawing efforts for the right time and place.

Simple beginnings

Every picture has a simple beginning; it has to be the placement. I found this step to be the most elusive part of painting. Can you believe that the beautiful paintings in museums were all started this simply?

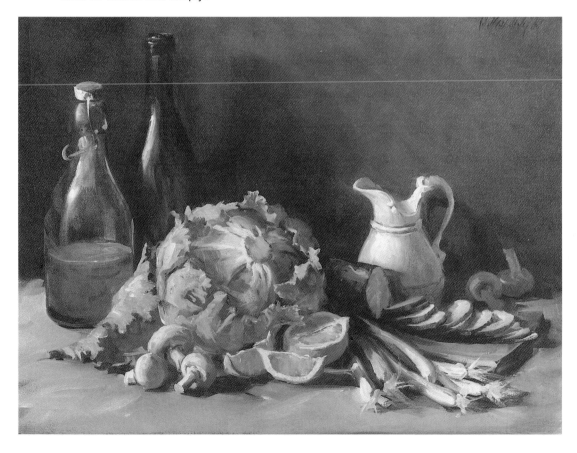

Starting a landscape

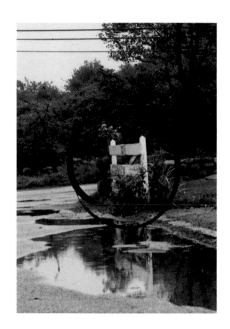

When painting portraits and still life, **I arrange the compositions.** But when painting a landscape, I see the whole outdoors and have to single out something that intrigues me. This different situation makes me have to start not from the outer edges of the canvas, but from my **point of interest.** I indicate the size and placement of it with a circle, taking into consideration how much surrounding area I want to include. A point of interest (the focal point) should never be located in the center of the canvas, as seen in the photo of the subject. See how I've moved it in my painting to the lower left third of my canvas. This gate is the entrance of our street and I can see it from my studio window where I spend many hours not only painting but also writing my books. The gate takes on many appearances according to the lighting of the days and the seasons. Coming back from trips, both business and pleasure, the gate is always a pleasant sight.

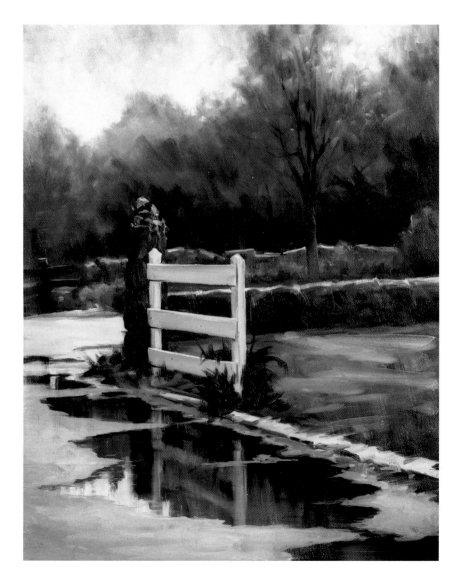

Fit and place the focal point on the canvas

Never put the focal point in the middle

2. The sphere — a fundamental shape

The clue to making a unified composition

Of the five basic shapes — the sphere, the cube, the cylinder, the cone and the solid triangle — the sphere, or ball, is the most fascinating. For one, on a grand scale, our earth and other heavenly bodies (planets, moon etc.) are spheres. Here on earth many objects are spheroid: most fruits, many vases in combination with cylinders, to name a few.

To use the word sphere for ball, we think of an environment and this is what you're actually trying to create on a canvas. You ask of your flat canvas the ability to portray a three-dimensional world upon it.

Understanding how lighting affects a ball is the clue to painting a beautiful harmonious, realistic environment on your canvas. This sounds like pretty profound stuff, but it's really kind of simple, and understanding it will serve you well in painting any subject.

Let's see how this premise works in recording a simple still life arrangement with profoundness as well as learning how important it is to *see the light* on all subjects.

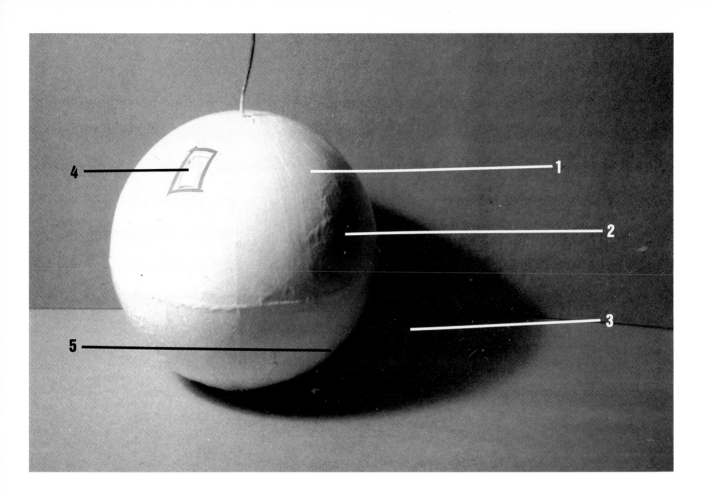

The 5 tone values

Hiding out in the colors on the palette are the most precious factors of painting — **the five tone values.** They are absolutely essential to recognize and learn about because they are caused by lighting which is actually what we see. **Without light nothing appears,** so it's lighting's appearance on things that provokes us to paint. Since light travels in a straight line and falls on three-dimensional things, the five tone values appear. They are:

1 The **body tone** where a form is in line with the light.

2 The **body shadow** where a form's shape is not in line with the light.

3 A **cast shadow** where a form stands in the way of the light.

4 The **highlight** where a concave or convex plane is in direct line with the light.

5 A **reflection** where general illumination bounces into shadows.

You will not be able to paint realistically if you don't make seeing the five tone values a priority. You may think it's color, or smooth paint, but **realism and dimension are synonymous** in painting. The five tone values are the two-dimensional surface's answer to recording our three-dimensional world.

I've used this old ball for twenty-two years to demonstrate how light causes the five tone values to appear. It's shopworn, that's true, but the old veteran has served me—and my students—very well.

The red overlay shows that a tonal sphere is the basis of these pictures' dimension.

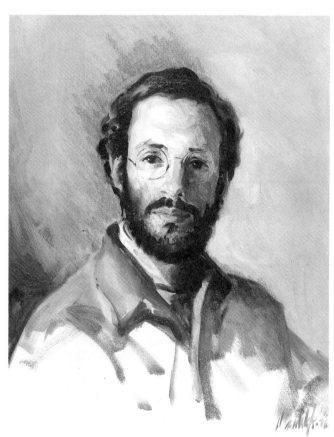

These subjects look real because they look three dimensional. They seem to take up space and have a feeling of depth. My way of understanding how to make a three-dimensional effect appear on a two-dimensional surface comes from a strong appreciation of how lighting influences my subjects.

Seeing subjects in dimension

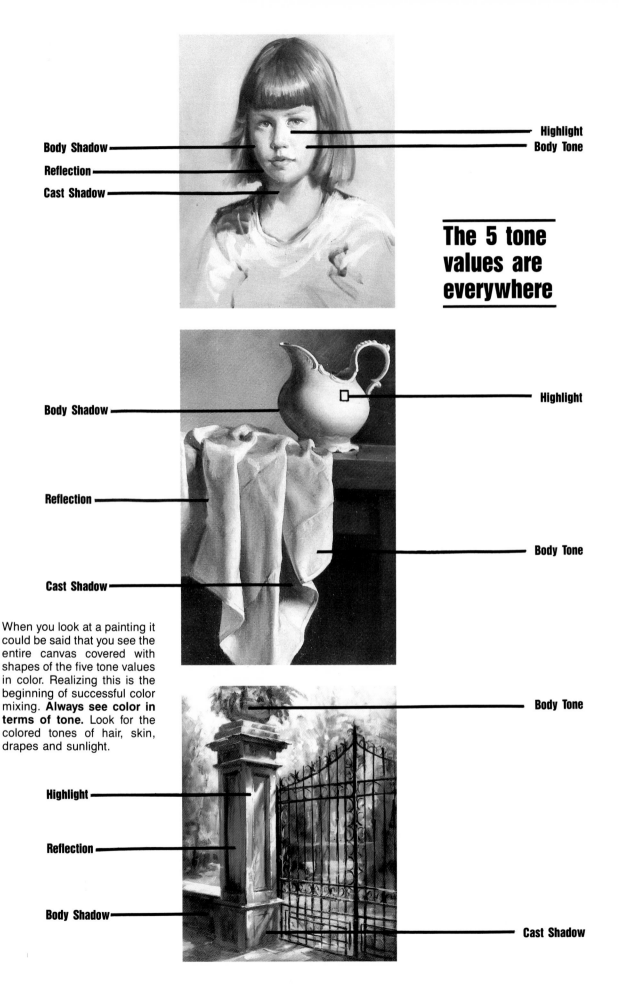

Highlight
Body Tone
Body Shadow
Reflection
Cast Shadow

The 5 tone values are everywhere

Body Shadow
Highlight
Reflection
Body Tone
Cast Shadow

When you look at a painting it could be said that you see the entire canvas covered with shapes of the five tone values in color. Realizing this is the beginning of successful color mixing. **Always see color in terms of tone.** Look for the colored tones of hair, skin, drapes and sunlight.

Body Tone
Highlight
Reflection
Body Shadow
Cast Shadow

3. Layers of paint are layers of thought

A way to think like an oil painter

The difference between the blank canvas and the magnitude of the reality of the subject is overwhelming. The empty canvas seems so far removed from the actuality we hope to record.

To expect our paint to record this reality in one layer is virtually impossible. To do so is asking your paint to be almost omnipotent. Yet we have seen magnificent paintings in the museums done by masters that record the gleam in someone's eye, the shine in someone's hair, the reflection in still water and the fuzz on a peach. So how is it possible to make paint function so beautifully? It needs a practical step-by-step approach, each one simple enough to execute, each one accomplishing just part of the subject's magnitude. It seems almost too elementary to say, "Start at the beginning." Appropriate here would be the advice my mother gave me when, as a new bride, I asked, "What am I going to do? I can't cook." Her answer was, "Start on time and keep the flame low." That advice has helped me as much in painting as it has in getting a meal on the table.

Let me show you how a progression of layers of paint if guided by layers of thought can accomplish the magnitude of turning reality into paint.

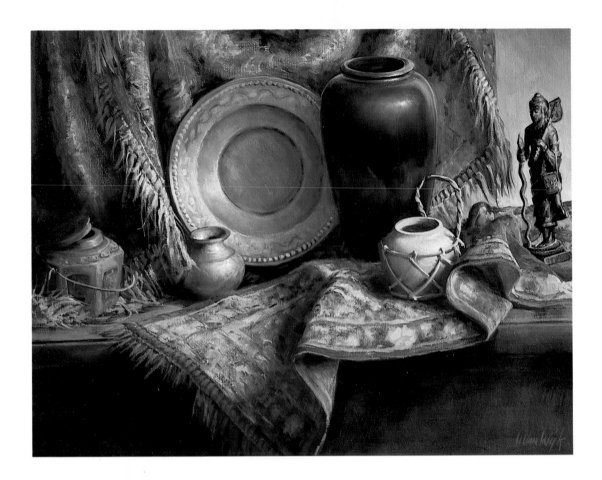

The actual subject

You can see the difference between the actual and the pictorial. By doing it in stages of development, I had chances to make **pictorial adjustments and artistic interpretations.** The four stages on the following two pages show my progress in reverse. Each stage show a layer of paint that records a layer of my thinking.

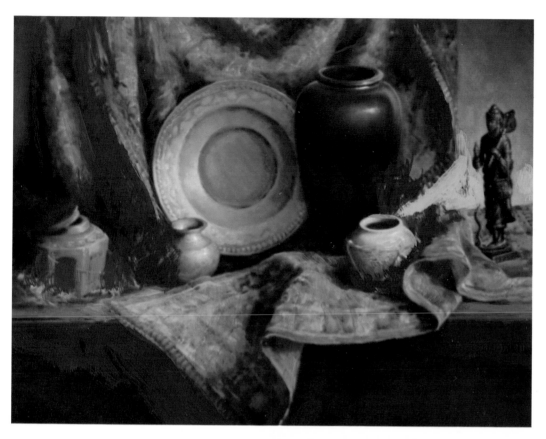

4.
almost
finished

This stage shows that I have developed the body tones, body shadows and cast shadows of the subjects and their surrounding areas without the lightest and darkest tonal accents.

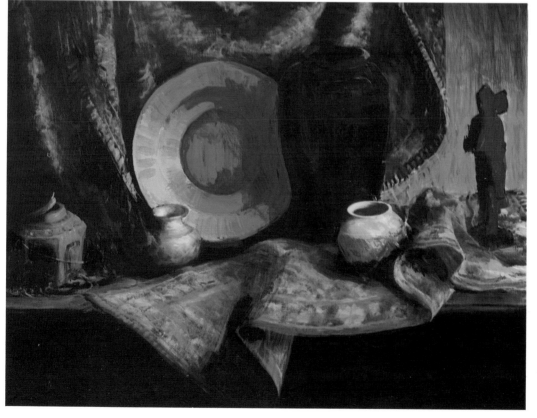

3.
the
color
stage

Here is the way my painting looked when I had painted in a layer of color over the gray stage seen on the next page.

2. Seeing the composition in tone

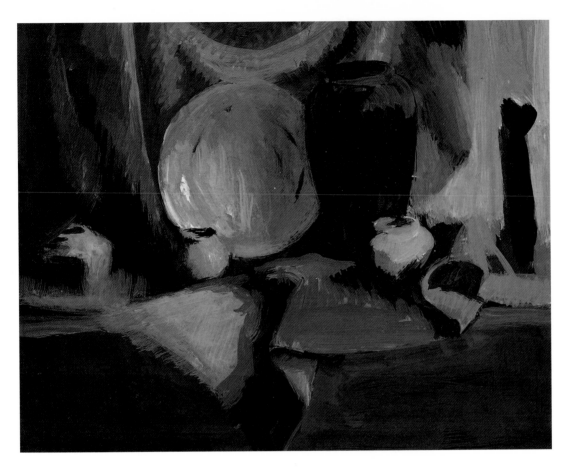

I always establish the tones of the composition before working on the color. I don't need color to establish shapes and dimension.

1. The all-important placement

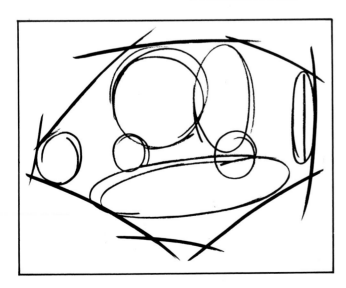 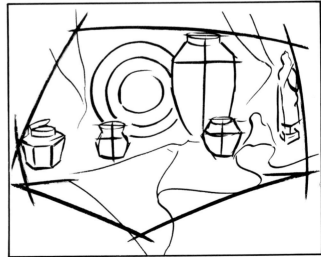

The placement-and-construction stage is the exciting time to begin adjusting the actual to a pictorial rendition.

4.
The beauty of gray

It's really a color

A painter can never think of anything as colorless. The painter is always recording how a subject looks to him. He always sees things influenced by a lighting that intrigues him, and lighting always causes even colorless things to be colorful.

There are many gray things in our world: The rocks by the seashore, the sky on a rainy day, the gray of fishing shacks and old barns and, of course, the color of pewter and silver. Upon closer inspection, gray imparts great beauty to colorful objects. Can we deny that the shine on apples, the haze on plums, the mist in the meadow and, yes, the fuzz on peaches are actually the color gray? If we do not appreciate gray as an important color on our palette, our renditions of our colorful world will look raw instead of atmospheric.

I'd like to show you how important it is to look for gray and the beauty it bestows.

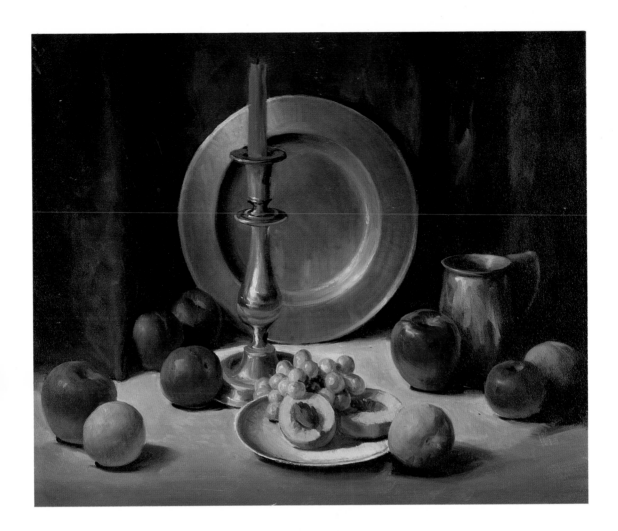

Gray — It is more than just black and white

It's easy to see the gray color of the pewter candlestick and tray but the color gray has also been employed to make the other colored objects look real. Light not only causes the five tone values but makes color appear as it does, and lighting imparts an atmospheric look to color. **The color gray is the artist's substitute for nature's atmosphere.** How do you make it? Black and white is almost the simple answer. The pewter was painted with tones made of black and white with slight additions of color: Yellow in the gray where the light strikes; violet grays (yellow's complement) in the shadows. Slightly colored grays were also used to paint the shine on the plums and the apples.

What a difference a gray makes

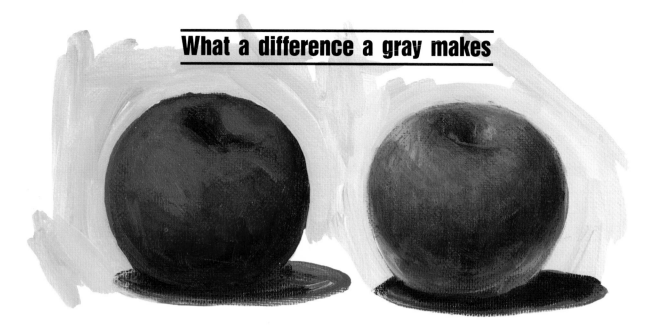

Always mix a little bit of color into black and white to make beautiful grays

See how the color of the apple on the left doesn't look as real as the apple on the right. A light gray mixture of black, white and Sap Green, Red's complement, was painted into the red color to impart luminosity. Basic apple color: Grumbacher Red and Alizarin Crimson.

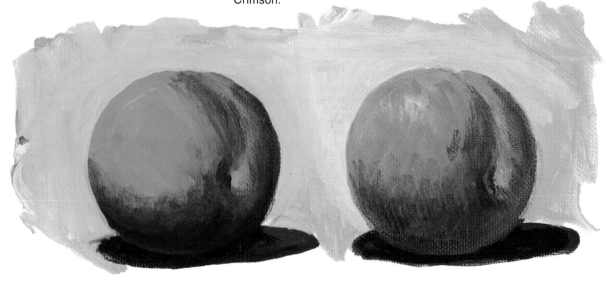

A light tone of black, white and a touch of Alizarin Crimson was added to the basic color of the peach: White, Yellow Ochre and Cadmium Red Light (shown on right). See how gray has improved this peach's color and appearance over the one seen on the left.

It wasn't long after I had started to paint at age 11 that I went to study with **Ralph Entwhistle,** a very busy illustrator and fine teacher. At a young age, most of us have very few pre-conceived ideas—right or wrong. The learning process, therefore, is easier. Mr. Entwhistle stressed the influence of gray on color and had actually invented a line of gray paints in various values to mix with his colors. He was not alone. **Frank Reilly,** a famous and popular instructor at New York's Art Students League advocated using gray and he, too, had a line of gray paints manufactured (by Grumbacher) to his specifications. Years later, when I studied with **Maximilian A. Rasko,** I used four values of grays called Illustrators Grays (renamed, today, Grumbacher Grays) because Rasko's color theory was also dependent on gray. You can see, then, that I was weaned on gray. Then, when I started to teach, I decided that students would learn more about tone and color by mixing color into black and white to make colorful values of gray instead of using pre-mixed ones. I painted Ralph Entwhistle's portrait in 1961 (shown here), many years after I had studied with him. While he posed, he asked me, "Remember what I used to say?" "Yes," I answered, **"When in doubt, use gray."**

5. Reflections in water and other shiny surfaces

How to achieve intricate textures with paint

The texture of things fascinates the eye. Writers have often waxed poetic about the shimmer of light on water, the beautiful glow of precious woods. The artist, too, has been fascinated by these textures. So much so to even make them focal points in pictures.

We marvel at paintings that successfully record a reflection of a boat in still water or a reflection on a table from a bouquet or a candlestick. We seem to see the reflection down into the surface of the wood or the depth of the water, and yet we see the surface too. And so, we ask the flat canvas to record two dimensions: down as well as across. These very words — down and across — will direct the way to paint reflections. The following steps will show you how to go about achieving reflections in water; you will be able to use this technique whenever you are faced with a reflective surface.

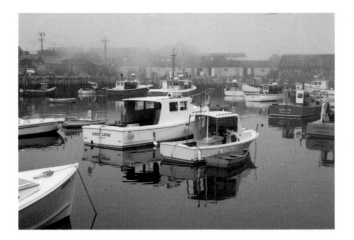

Reflections in water

Rockport Harbor with boats in its still water is just down the street from my studio. This is a favorite subject for amateurs and professionals as well. **The professional makes it easy,** realizing that the reflections are an upside-down version of his subject. The student painter, on the other hand, often cannot simplify what he sees.

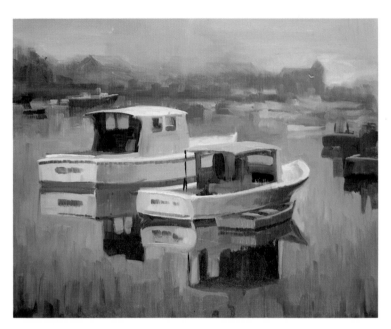

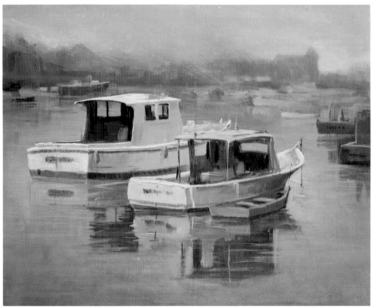

The entire water area was painted in **downward strokes** with the tones and colors of the reflections. The finished picture shows how these downward strokes were moved with **across-strokes** to show the slight movement in the water. Some light gray tones were also stroked over the water area to impart a shine to the surface of the water.

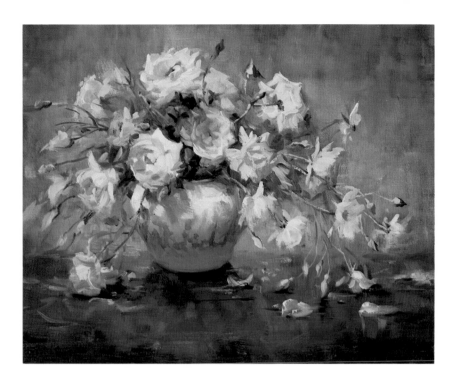

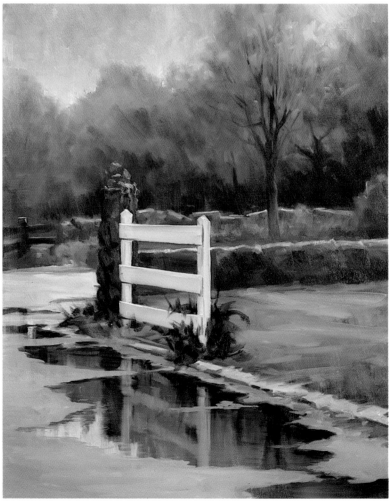

Put it on one way, effect it another

The puddles in "Watergate" (at left) were done with "the first up-and-down-second-across-stroke technique" as was the table in the picture "Roses '88." How **mirrorlike or vague** you want your reflections to be will be determined by how in focus you paint the up-and-down strokes and how much blending you do with the subsequent across strokes.

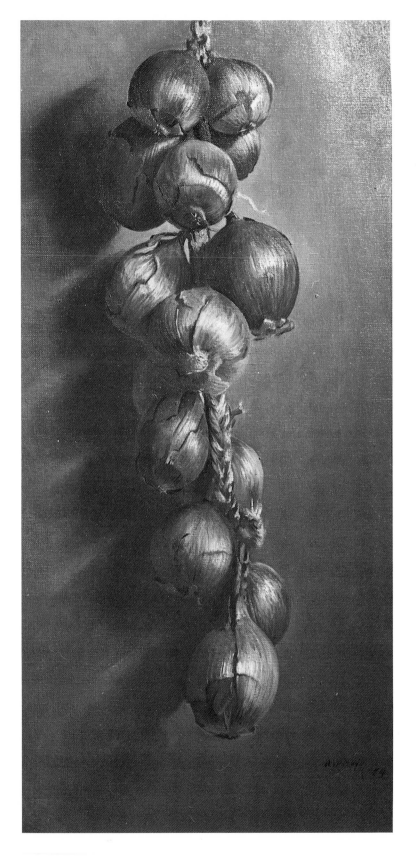

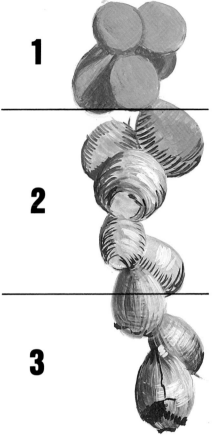

1

2

3

1 The mass tone of the onions.

2 The lights and darks done in across strokes.

3 The final strokes show the texture of the onion skins.

Save the final effect for last

6. The cone-shaped flowers

The key to painting daisy-type flowers

When we think of a cone our thoughts are apt to go to the joys of ice cream and the long, conical containers that house the dairy delights. Our initial thoughts, therefore, are far from recognizing a flower as a cone. The dishlike shape that the many petals make surely is conelike and seeing a flower's anatomy as a cone will help you make a painting of a flower look dimensional and sensible.

There are many cone-shaped flowers, a daisy being the prime example with a cosmos running a close second. Petunias, too, are cone-shaped, and the hibiscus is the tropical version of that type of cone flower. All kinds of day lillies are also cones; they are easier to recognize since they are deep. And black-eyed susans should be thought of as cones except that they are more like inverted cones because their petals hang down from their bottoms.

The cone is one of the five basic shapes. As a painter, you have to know how one source of light influences this shape. This basic understanding will tell you which petals to make light, which petals will be in shadow. Seeing the flower as a cone also helps you to paint the flower's form in perspective, meaning the recording of the flower's shape as it faces you, its side view and the back view, as well as making you paint the stem correctly.

Knowing flowers to be cones, as you see them as things of beauty, will fortify your interpretation of them on canvas, making them look sensible as well as lovely.

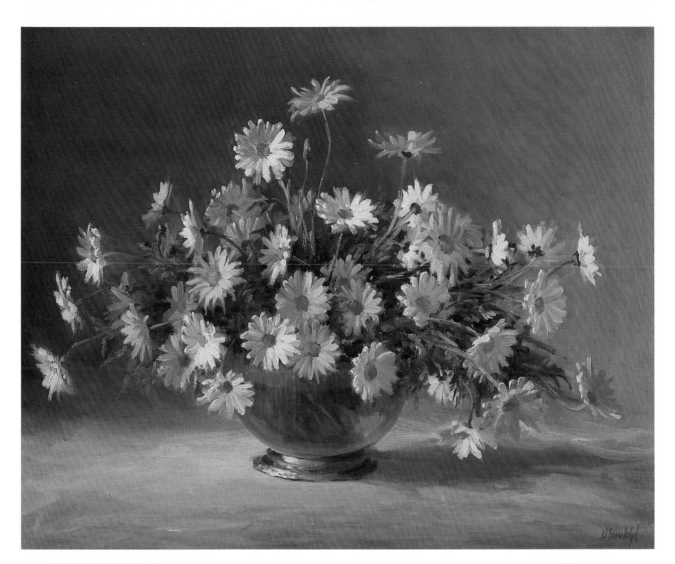

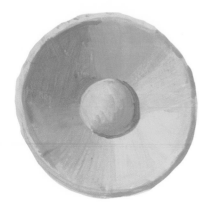

Most flowers are cones or a combination of a cone and cylinder in perspective

Knowing how lighting affects a basic shape will enable you to see the shadowed area of a flower more easily. The petals of flowers seem to obscure this shadowed area. Without it, flowers look flat.

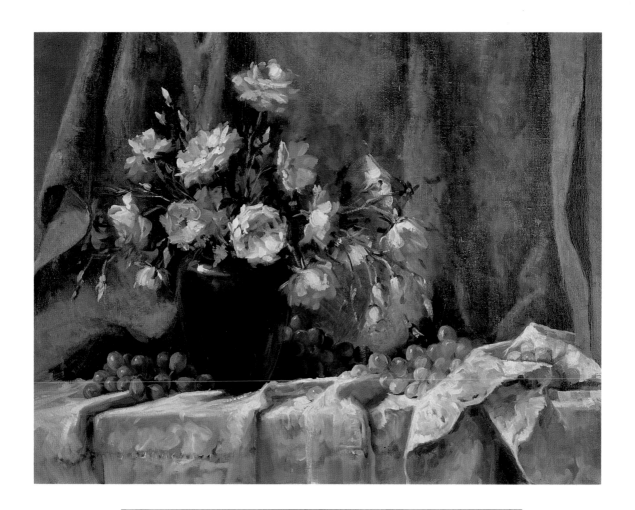

Basic shapes help you paint convincingly

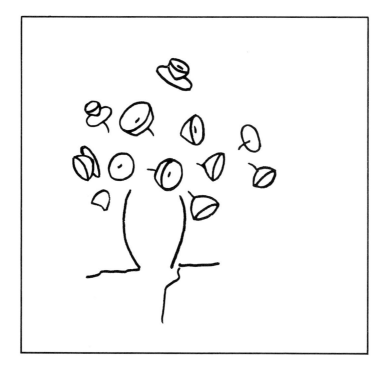

This diagram shows the anatomy of the roses in the painting above as cylinders and cones in perspective. Don't mistake this to be the way you should draw flowers. It is a diagram of how you should think about the shapes you see. With this understanding you will see and paint a better mass tone shape and will recognize the lights and darks that are important. Always look beyond the detail and see basic structure.

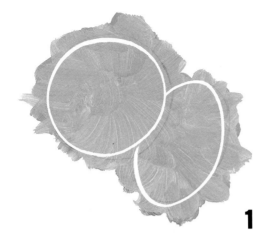

1

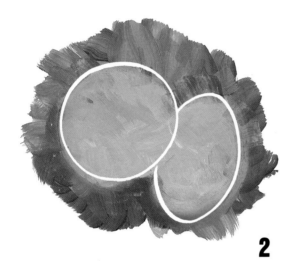

2

Four steps to paint any flower

1 Mass in an area of paint to represent the flowers. This should be bigger than the flowers actually are.

2 Mass in a contrasting tone to cut that painted-in area down to size.

3 Repaint the flower area with petal-like strokes.

4 Add lighter tones to the petals that are in line with the light. Note: The diagrams on Page 40 will help you see where these lights are.

General color mixtures for flowers

Use a grayed version of a flower's color for Steps 1 and 3 — black and white into a flower's color. Add the light tones of flowers by mixing the flower's color into lots of white.

3

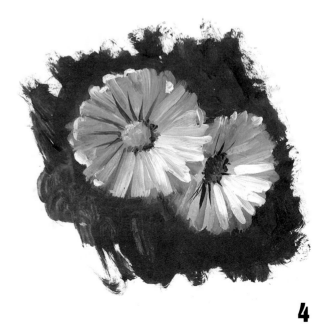

4

7.
The background's effect on color

A subject's proper setting

The beginner painter is enthralled with his subject. He sees pretty red petunias and says, "I must paint them." He picks the flowers, squeezes out his colors and then finds that the petunias' color is too difficult to recreate.

The professional painter, on the other hand, sees beautiful red petunias, fully realizing how difficult it is to record their color. He picks the flowers, takes them into his studio and then makes painting them easier by carefully choosing a background that will show off their color.

The professional is a person who knows how difficult a subject is and tries to find a solution to its difficulty. The amateur thinks he has to overcome the difficulty with his talent.

In every picture there are positive and negative spaces. The positive is the name for the subject; the negative, the space that's left over, supports it. Recognizing this relationship is a *must!*

Something could look just fine in reality but this reality has to be adjusted to the flat surface. You always have to compensate for the limitation that the flat surface imposes. When you see flowers in a garden and are inspired to paint them, realize that there is a difference between the actual and the pictorial; you will have to give them a setting that will show off their beauty.

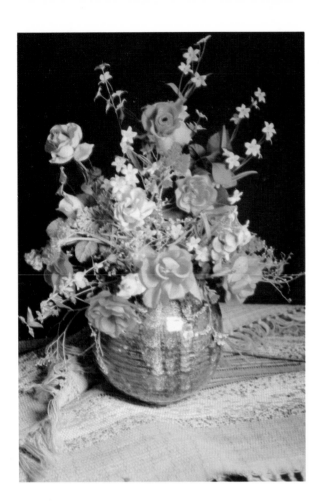 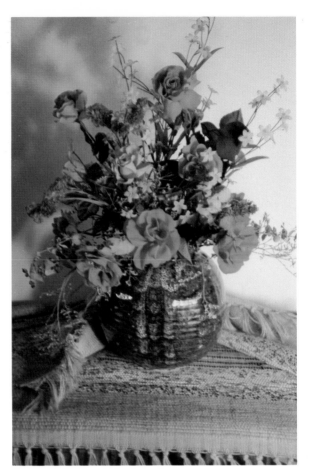

Backgrounds: A subject's show-off

In the two pictures of the same bouquet, see how the different backgrounds have changed the tones of the flowers. Against the dark background the bouquet looks light, but it looks dark against the light one. Since **it's a good practice to overlap color** in order to cover the canvas well, ask yourself the following question: Should I paint in the flowers first or the background first? The best procedure is to paint in the more fragile color first so the stronger color can be painted against it.

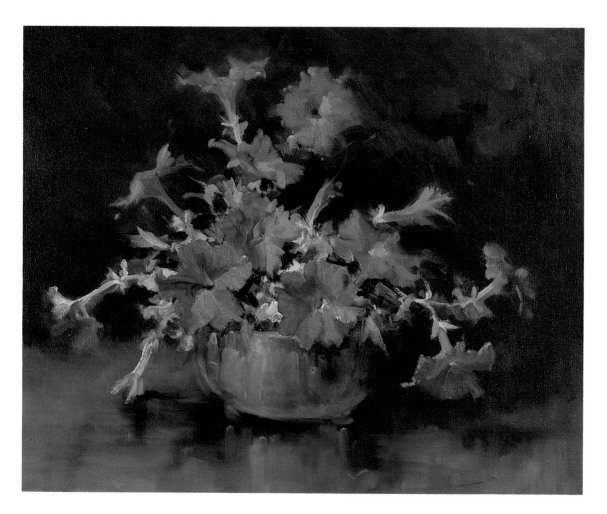

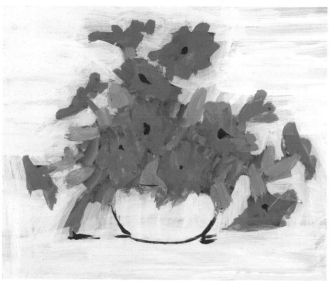

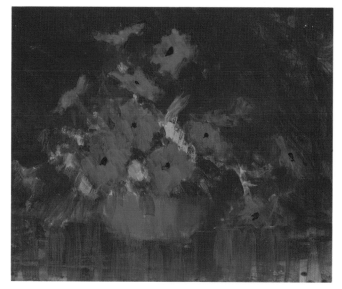

Start with the fragile color

I decided to do petunias against a **dark background.** Deciding that the red color was the more fragile color, **I massed the red flowers in first.** I then cut the red color down with the stronger background color. Had I wanted to paint petunias against a **light background,** I would have painted the light **background first;** trying to paint a light background around wet, red flowers would be difficult. I surely would end up with red bleeding into the background color.

A lighter type background presents an airy atmosphere for a bouquet. See how the flowers are in contrast to the background: Some darker, the white ones lighter. You may miss seeing the color of this picture but its composition and its mood are certainly obvious in black-and-white.

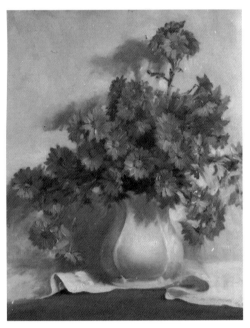

A background menu

I can't teach you what background to use; it's **a matter of taste.** Painting flowers against a light background is the most difficult. I like to use the background that's shown in the painting on the right, ranging from light to dark. It's dramatic.

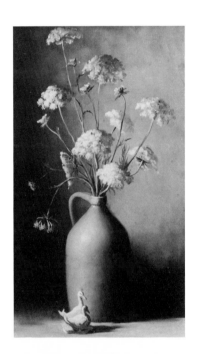

Making your subject light in contrast to a dark background is easier to paint, because the focal area is well defined by light tones and colors in contrast to the dark, less vibrant-colored backgrounds. **Backgrounds are not easy to choose or to paint.** They have to be suitable, show off the subject, they take a lot of time to paint, and yet have to remain in the distance.

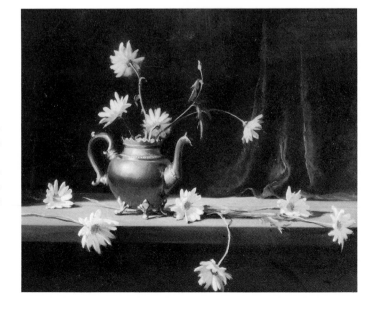

8.
Dimension's best friend

Cast shadows

I f I were asked what my favorite tone value in painting is, I would say it's the cast shadow. My favorite, yes, but certainly not the most important since *all* the tone values — five in all — are important.

I love to see cast shadows, love to find them, love to paint them. Not only because they add so much dimension to the flat surface: they also make apples sit on the table, they make a nose jut out from the face, they make trees look like they're in the foreground; more important, though, cast shadows contribute strong drama to a composition. In fact, dramatic, realistic compositions cannot live without cast shadows.

Whenever I set up a still life, I search for beautiful patterns of light and dark. I arrange my subject matter and lighting to see cast shadows. I want them for compositional patterns; I need them for dimensions.

I'd like to acquaint you with the power of cast shadows and teach you how to paint them.

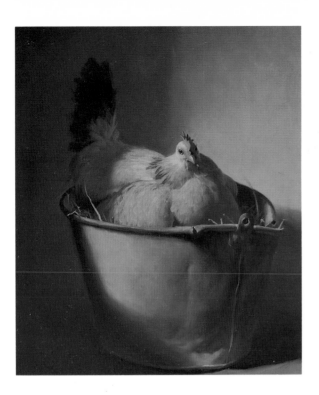 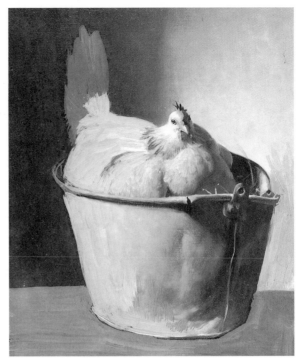

The color and tone of cast shadows

My friend owns the model for this painting. It's a stuffed chicken in an old bucket. Although fascinated with it, I felt the chicken needed an interesting setting. I decided to paint the chicken half in shadow. See how different it looks without the big cast shadow (on the right). **Cast shadows add** so much dimension and can be used also for **compositional impact.**

1

First notice how dark the cast shadow tone is.

2

The color of a cast shadow is made by darkening a mass tone color and adding that color's complement. In this instance, the cast shadow falls on four tonal versions of yellow: The background, the chicken, the bucket and the floor (all tones of black, white, Burnt Umber, Burnt Sienna and Yellow Ochre).

So the cast shadows are darker mixtures of black, white, Yellow Ochre, Burnt Umber, Burnt Sienna, some Thalo Blue and Alizarin Crimson, making the mixture slightly violet. This cast shadow mixture should be relatively complementary to the color it is on. **A red apple does not cast a green shadow,** as so many beginners seems to think. The cast shadow is complementary to the color it's on not to the object that casts it.

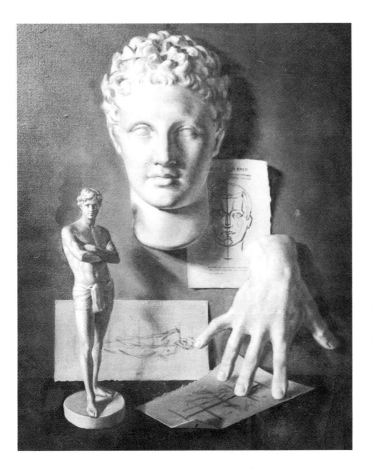

Things cast shadows do

All the cast shadows in this painting are indicated in the diagram. See how the cast shadow makes the nose stand out, how the paper stands out from the wall, and how the objects sit on the table. Without these cast shadows, the subjects wouldn't look like they take up **space on a mere flat surface.** Always arrange to look at your subjects, be they people, still lifes or scenes, in such a way that you see cast shadows. Painting lighting that causes shadows makes a dimensional effect possible and contrasts that make dramatic compositions.

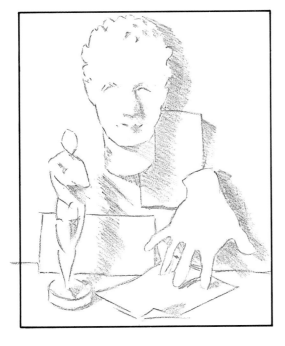

Dramatize the ordinary

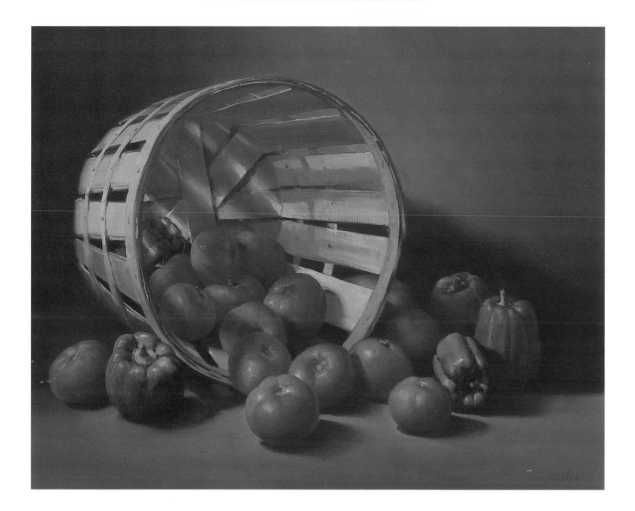

The light passing through the holes in the basket, striking the vegetables, presented irresistible lighting. My main source of inspiration comes from seeing how lighting plays on colors and shapes. One summer, I had a bumper crop of tomatoes and peppers and I arranged them spilling out of an old basket. It wasn't until I put a spotlight on the setup, creating dramatic lighting, that made me paint, instead of making spaghetti sauce. There are wonderful subjects all around you. **Add dramatic lighting, and subjects become possible pictures.** Remember, without light you are without contrasts of light and dark colors and without the opportunity to paint dramatically and dimensionally. Color mixtures for this painting are: Wherever you see the colors in light, the actual color of the subject is mixed with a lot of white. The **basket:** Cadmium Yellow Light, Thalo Green and white. The **tomatoes:** Grumbacher Red, Cadmium Red Light and white. All of these light tones are further enhanced by a light gray highlight that's made of white and black. The shadows on the tomatoes were made by putting a touch of Thalo Green into their red color; the peppers' shadows were made by putting red into their green color. The shadows on the basket were made by mixing a gray violet (black, white and Alizarin Crimson) into Yellow Ochre, Burnt Sienna and Burnt Umber.

9. How to paint glass

Colored and clear

Many people marvel at my paintings of glass. They ask me, "How can you paint something that has no color?" And also, "How can you make paint look like glass?" But paint can be made to look like anything, if you think about it. I can make my paint look like flowers, like skin, like copper, like water, so why can't I make paint look like glass?

We have to go back to the basic painting premise that paint can do anything that light can do. Light causes color to appear in tones of light and dark. Paint is basically color and tone.

Of the five tone values that I so often talk about, which are the body tone, the body shadow, the cast shadow, the highlight and reflection, the last two play the most important roles in painting glass.

Light shining on colorless glass causes only highlights and reflections to appear. On colorless glass, there is hardly a visible body tone or body shadow. Highlights and reflections dance on the surface according to the lighting and the object's shape. This happens on colored glass as well.

This chapter inspects how important highlights and reflections are to painting colorless and colored glassware.

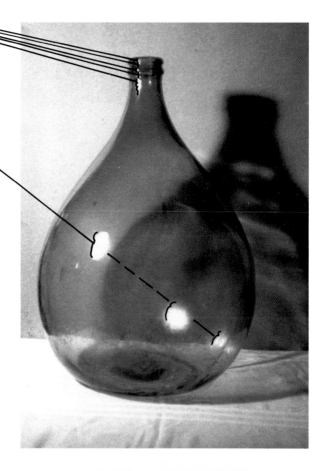

Look through the glass first

Light coming from the left, shining on this bottle, makes highlights appear on the concave and convex planes in line with the light — **six in all.** Because glass is transparent, **light passes through its surface** and shines on the back of the glass, too. The light that's seen on the back of the glass picks up the color of the glass. The highlight, however, is colorless and, at times, can be recorded with pure white.

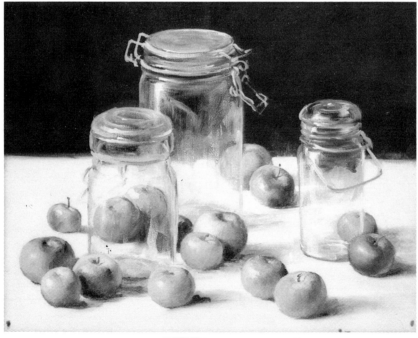

Painting in what you see through the glass first is the answer to painting glass and making it look transparent. The crab apples seen through the glass were all painted first, then highlights and reflections were added which recorded the front part of the glass canning jars.

Save the highlights for last

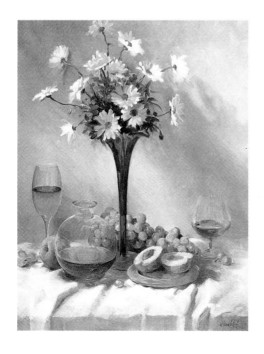

These three steps show a procedure I used to paint **After Lunch** (pictured in color on page 54). They will help you to understand how everything has to be painted in preparation for the tones that record glass: Highlights and reflections. **1.** The sketch; **2.** The background and the subjects without any indications of the transparent glass; **3.** Here, some lighter and darker reflections have been added to indicate the glass objects.

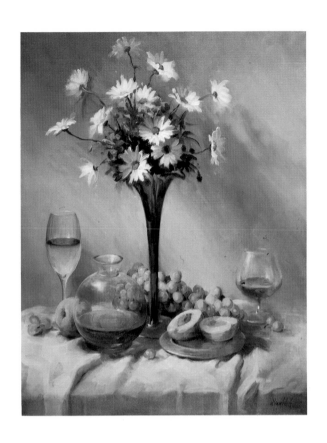

Glass and its highlights: handle with care

After Lunch. Now you not only see the glassware but see it shine because the highlights have been added to the decanter and two glasses. These final additions of tone have to be **painted carefully;** if **you goof,** you have to wipe them off and then repaint the tones of the back part of the glass—and then do them again.

New England Dinner. Colored glass is a little easier to paint because you can mass in a color to record the object's shape. Make sure that the color is dark enough to enable you to add the light shining through the glass in a light, bright mixture.

10.
Eyes
and
Expressions

How to make them look at you

How many times have I heard the remark "No matter where I stand in the room, the portrait always seems to look at me"? or "The eyes follow me wherever I go." I wish I could say that this phenomenon is a miraculous secret of my trade, or tell you that it's very difficult to do, but I can't because it isn't difficult. A camera does the same thing. The eyes in many photographs would also follow you around the room if the photograph were as large and lifelike as a painting.

When my model looks right at my eyes as I paint his eyes, the eyes in the painting will always look at whomever's looking at them from anywhere in the room. It's that simple. It's eye contact, as they say today.

Many years ago, I painted a model — Mrs. Jones — who had a habit of always looking up as she talked. She also looked up while she posed for her portrait. Some weeks later, at an exhibition that included my portrait of Mrs. Jones, a gallery visitor approached me and said, "I love your portrait of Mrs. Jones; she always looks at my ceiling, too."

I don't have to teach you how to make the eyes follow the viewer around the room. That's accomplished by having your model look at you, the painter, but I can help you paint eyes that look sensible and so-called realistic.

How to make the eye twinkle

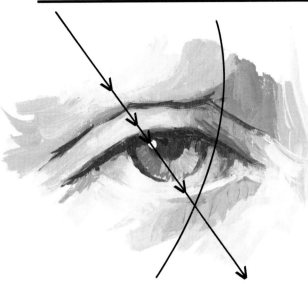

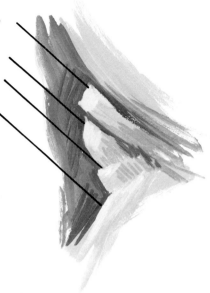

Instead of looking at the expression in someone's eye you must see his eye as **a ball in a socket and held in place by two lids.** How light shines on a ball is the clue to making the eye look sensible and so-called real. The lines in the eye on the left point this factor out by showing how the light only hits where the eye areas are in line with the lighting.

A

ABC shows how the artist records a model's expression by carefully recording the shapes around **the eyeball,** which in itself **does not change.** The shape of the model's eyebrow is a major contributor to expression.

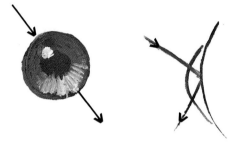

The iris of the eye is glasslike. The **highlight in the eye makes the eye twinkle,** and the color of the eye is directly across from the highlight. The light has passed through its transparency, much like it does to a bottle.

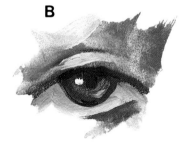

B

DEF shows that the eyes should be a matching pair and can best be done by painting both eyes with the same strokes: A stroke for the lid on the left eye, a stroke for the lid on the right one, and so on, as indicated by the consecutive numbers in the diagram. This helps you also with **foreshortening,** caused by **perspective,** a factor that stops them from being exactly the same shape.

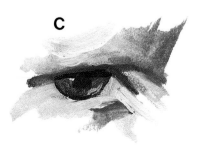

C

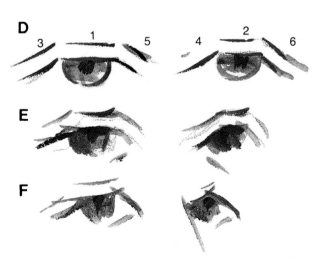

D

3 1 5 4 2 6

E

F

The eye — from socket to highlight

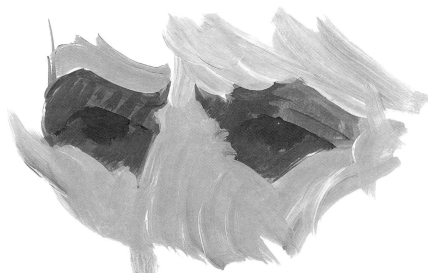

1 Start by massing in the shape of your **model's eye sockets, using shadowed flesh:** Yellows and reds mixed into medium gray made of black and white.

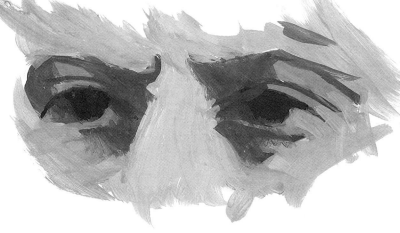

2 With a darker tone of gray — made of black, white and Alizarin Crimson — paint the darks, such as those that are caused by **the lids shadowing the eyeballs.**

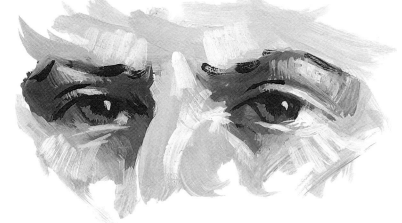

3 Then add any shape of light flesh tones that you see, usually on the upper lid, the thickness of the lower lid and just a bit on the white of the eye in line with the light.

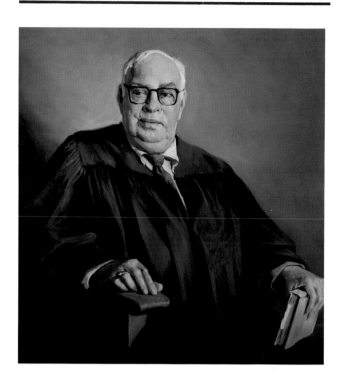

Judge Perocchi looked at me all the while I painted him. *Helpful hint:* Make the eyes a matching pair by **constantly comparing** them to each other. Paint them alternately: Repeat the stroke on one eye with the same stroke on the other.

Judge Jodrey's eyes were painted to look in a direction that disguised his strabismus condition (walleye). *Helpful hint:* **Don't paint the whites of the eyes white!** They are, in fact, grayed lighter flesh color, and only seen on the light side.

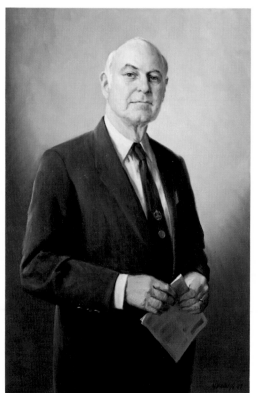

▶
Every feature of the face has to be painted discreetly, **especially when painting women.** *Helpful hint:* I had Edith Dean remove her glasses when I painted her eyes, and added them later when the skin color was dry.

Ken Spengler's portrait was to be hung above the viewer's eye level, so I painted it by looking up at my model. *Helpful hint:* **Decide whether you are going to look up, down or directly at your model.** It affects your model's expression.
◀

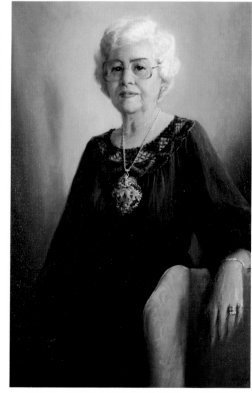

11.
The framework of solidity

Make it, break it, make it again

I n my many years of teaching I have found that the solidity of the things we see goes unnoticed. An example of this is that we describe a tiger as striped, a cascade of water as a waterfall, hair as combed and a tray as round rather than deep. When we only recognize and paint outer appearances, our subjects will look flat because they will lack the feeling of solidity and dimension that make subjects look really real.

The obvious characteristics are the first that are noticed but should be the second painted since solidity is the more basic element of any subject.

This chapter shows you how opposing brushstrokes can help you achieve the illusion of solidity as well as a subject's outer appearance.

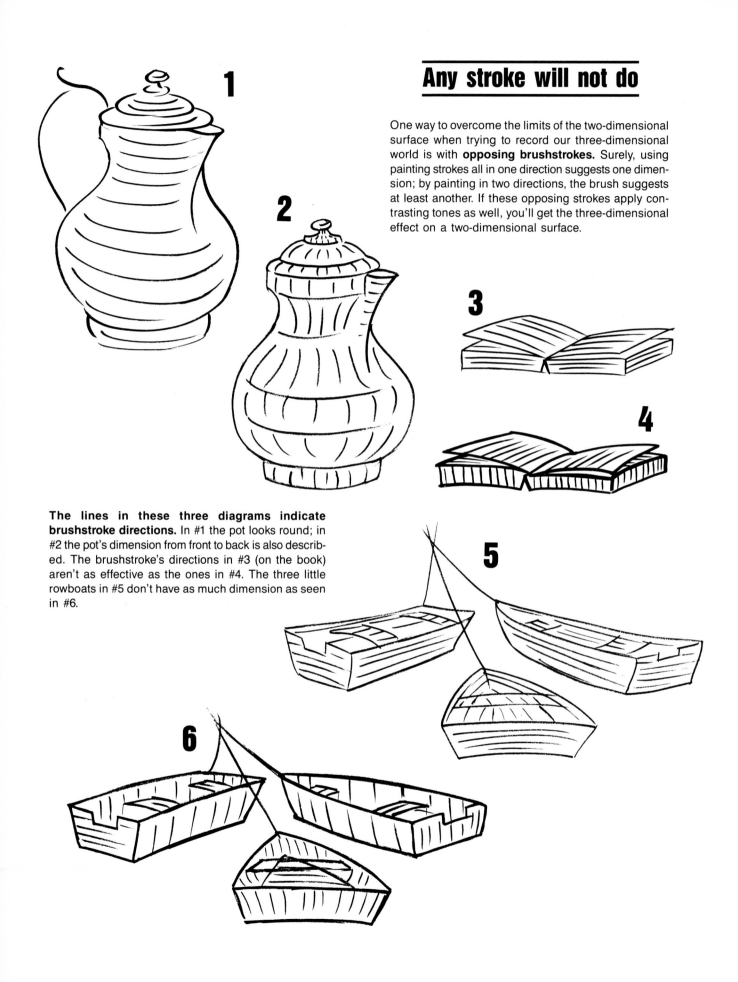

Any stroke will not do

One way to overcome the limits of the two-dimensional surface when trying to record our three-dimensional world is with **opposing brushstrokes.** Surely, using painting strokes all in one direction suggests one dimension; by painting in two directions, the brush suggests at least another. If these opposing strokes apply contrasting tones as well, you'll get the three-dimensional effect on a two-dimensional surface.

The lines in these three diagrams indicate brushstroke directions. In #1 the pot looks round; in #2 the pot's dimension from front to back is also described. The brushstroke's directions in #3 (on the book) aren't as effective as the ones in #4. The three little rowboats in #5 don't have as much dimension as seen in #6.

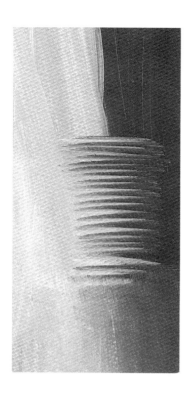
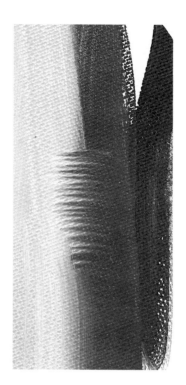

Don't try to blend and paint at the same time

Blending one tone into another is an ever-present painting procedure. One good technique can be used in all instances where blending is necessary. Notice how the little wiggle across-strokes move the light and dark tones together. These "teeth" can be blended away with a faint up-and-down dusting with a brush that's been wiped clean of paint. The technique I rely on is to paint in strong contrast first, then pull those two tones together and then blend them in the same direction I painted them in the first place. This is another example of painting in two directions — put it in one way, blend it in with opposing strokes.

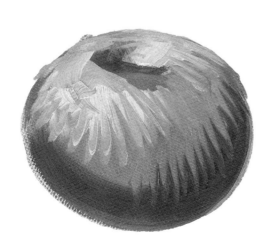

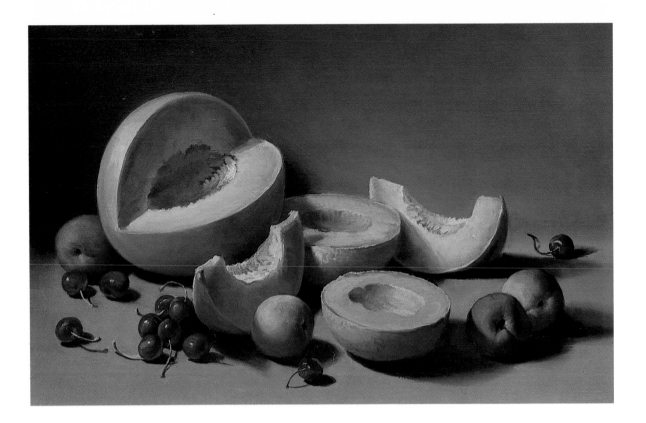

The front-to-back dimension

See your subjects in planes: Top, front or side ones; those in light or those in shade. The cut-up melons have obvious top and side planes. When painting, always think from **front to back** as well as **from side to side.** This will direct you to use better brushstrokes, as I've shown you in the diagram below.

12. The shine and shape of metal objects

Examine the highlight

Few still life painters can resist the allure of the beauty of the shine on copper, brass and silver. The museum visitor marvels at how glowing the metal objects are in the paintings of Willem Kalf (1619-1693), the Dutch painter known for still lifes.

To record the shape and shine of metals you have to direct your entire attention, first, to the structure and elements of the shape of the metal object and then to how the light affects the "ins-and-outs" of the object's shape.

It's hard to avoid repetition in teaching painting since basic principles apply to everything, but let's carefully examine metals and their shine and you will find the secret to how to record them.

This chapter will point out how to look for the ins-and-outs of a metal object's shape which more artily can be referred to as the object's convex and concave planes.

Painting a metal object is a good way to learn that highlights are seen on convex and concave planes. Highlights are so easily seen on copper and brass. Highlights are ever-present on most textures. On some, they are ever so subtle. The highlight is one of the five basic tone values, not more important than the other four but when painting metals its dramatic contribution to its appearance is the one you should focus on.

Highlights make shapes show

Highlights hit on planes that are in direct line with the light. In order to paint them, you have to find them, so inspect subjects carefully to find their many highlights. My way of examining subjects to find their planes is to inspect them from the top down and actually count the number of planes or elements of their anatomy. **The copper can, pictured here, has nine elements to its overall anatomy.** Each one contributes to its appearance. How can you record them with paint? By painting **nine highlights,** one for each plane.

1
2
3
4
5
6
7
8
9

Highlights make shapes shine

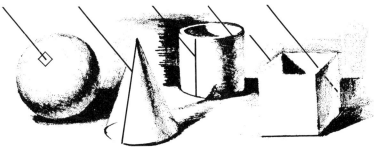

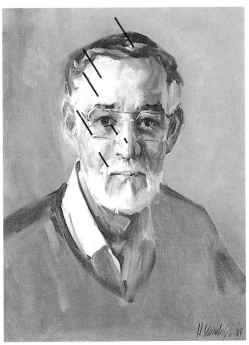

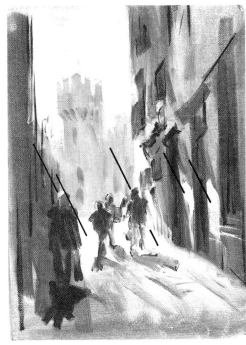

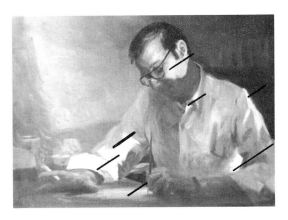

There is an area on many shapes that is concave or convex. When it is in direct line with the light, a highlight appears. The highlight's appearance depends on the shape's texture. Concave or convex planes on glass have highlights that are very light and stark but highlights appear on the planes of duller textures, as well, such as on the iron pots that are shown. The human face has many concave and convex planes. The highlights on these flesh areas make the skin glow with life as well as describe the features they're on. In landscape painting, I consider sunlit areas highlights. The major characteristic of a highlight is that **it is the lightest tone on a subject.**

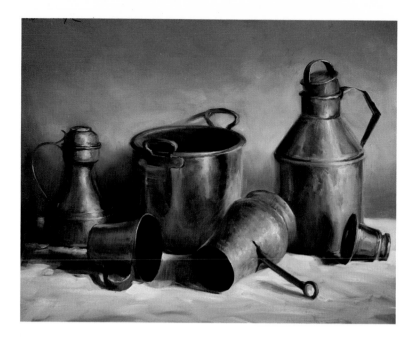

Highlights make all metals look shiny. The color of the highlight on copper is white mixed with Cadmium Orange and Cadmium Red Light. Brass highlights are white mixed with Cadmium Yellow Light. Since the brilliance of the color of highlights on metals is exceptional (most highlights are off white) and metals' most distinguishing features, it is best to paint in the highlights first and then cut them down with the basic body tone. This procedure keeps the highlight colors cleaner than applying them onto the body tone.

Start metals with a highlight

1. Paint in the highlight color bigger than you actually see it.
2. Cut this bright, light color down with the basic copper color of Burnt Sienna and Cadmium Red Light.
3. Repaint the highlight. I call this procedure: **Make it, break it, make it again.**

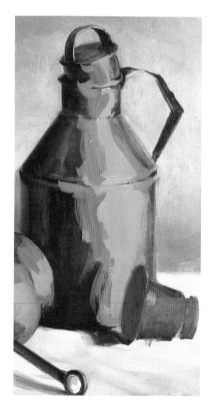
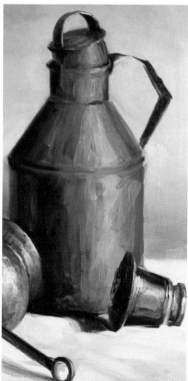
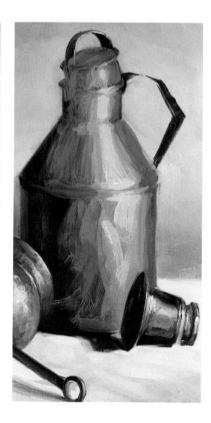

One highlight per customer

One source of light causes one highlight per plane. Putting in a lot of highlights just because you see them does not benefit recording the object's shape. Our modern-day lighting makes highlights dance all over the object's texture. These should be ignored. Only see and **paint the ones that describe the plane's shine and shape.**

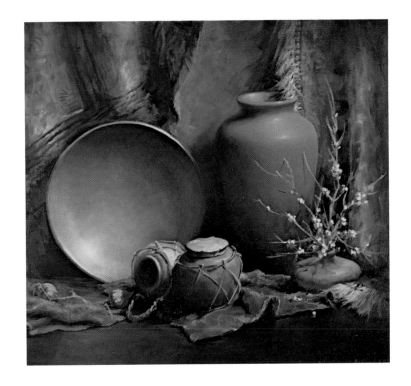

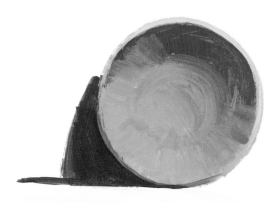

1 The brass tray has two planes: Rim and bowl. Notice how the tray was painted with two highlights, one on the rim and one on the concavity of the bowl that was in line with the light.

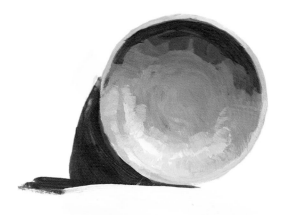

2 Don't be afraid to paint in a highlight, blend it in, paint it again, blend it again, until you think it looks right. It can't look like a white spot; it's got to look like a beautiful highlight.

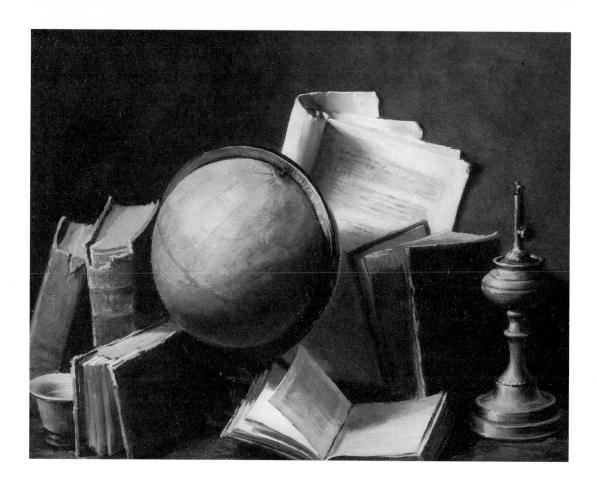

In this still life, there's a sphere, two cylinders and many cubes, three of our basic shapes. All these shapes have highlights. Search them out. **Here's a hint:** there are about 53 of them, each one falling on a plane that's in line with the light. The diagram below shows you where they are.

The problem with highlights is finding them, not painting them

13.
The center of your picture's interest

The focal point

A focal point is the very essence of a painting. In some students' work, it is often lost in the shuffle by a student's involvement with drawing, color, tone and technique, not to mention mediums and paint.

The focal point can be called the seed of your painting: it has to be fertilized by composition, drawing, tone, brushwork and color, and not obscured or confused by painting elements.

A painting that lacks pictorial impact is one without a well-defined focal point. I really believe that if I make a student aware of a focal point, he will automatically paint one. He will make all the painting elements slave for it. A painting without a focal point — or a weakly rendered one — comes not from lack of ability but from neglect. Good composition is a strong contributor to a well-defined focal point. I would like to dissect pictorial composition for you so you will use the component of composition more forcefully. Of course, I can't teach taste or interpretation, but there are some good rules that can be learned and respected.

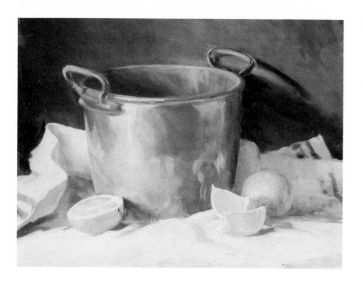

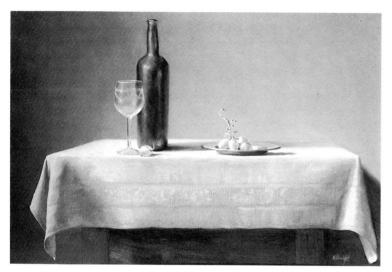

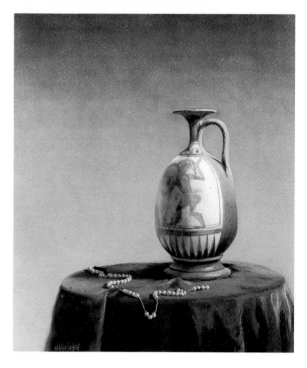

Unity, variety and balance

The Copper Cooking Pot is an example of a simple, basic composition. The pot is off center (never put the focal point in the middle). The lemons overlap the pot and each other, which **unites** the composition. The arrangement becomes one shape.

Harry's Bar Revisited. The manner in which a picture is painted can **unify** a composition as well as present a unified theme only if **the technique is consistently** used throughout the picture.

Dessert Wine. Since the focal point can never be in the middle and **balancing** it is an important asset to composition, **balance** in painting is like balancing weights on a seesaw. The further the picture's **weight or interest** is to one side, the further away it needs something to pull your eye to the other side.

Etruscan Vase. The unity and theme of this picture is the repetition of round shapes. The **variety** comes from their **drastic change of size and character:** The round vase in relation to the large round table and the smallness of the round beads.

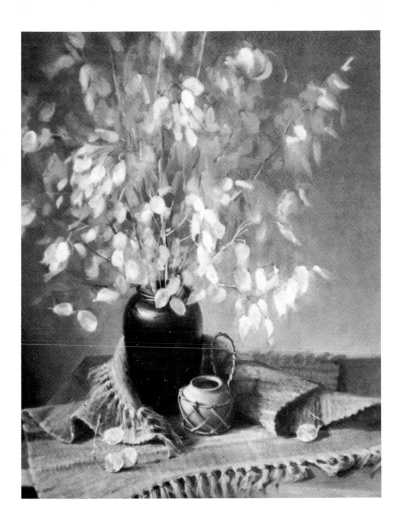

The 7 Components of Pictorial Expression

1. **Motivation**
2. **Composition**
3. **Tone**
4. **Color**
5. **Rhythm of Application**
6. **Shapes**
7. **Lines**

On page 16, I introduced and described the seven components of pictorial expression. Now, I'd like to explain how I dealt with them to paint this picture.

One day, as I looked at the small hand-woven rug, I came up with the idea that my black vase would look nice on it. That thought became my focal point which expanded, by quite a bit of experimenting, to be **composition,** as seen. I added the gingerpots for more interest and the Honesty **(lunaria annua)** to justify the vase's very presence. After settling on my subject matter, I started to paint, guided by my respect for the **power of the painting components.** I placed the **focal area** to the left and lower than the center of the canvas, giving me room for the Honesty. The Honesty and gingerpots can be compared to the backup melody of a symphony; an important contribution but not the major theme. □ I used my **tones and colors** for the materialization of my artistic choices; they are the **workhorse components.** I don't paint just what I see; I interpret what I see as artistically as possible. I feel completely uninhibited at my easel; I can make the colors as bright or as dull as I want; I can interpret the tones in sharp contrast or very vaguely, and I can reduce or enlarge shapes. Many people call this "poetic license," I call it **practical, artistic solutions to funny looking pictorial problems.** In the final analysis, I start out with the fifty-fifty chance of a mess or a masterpiece. I always end up with the best compromise I can make.

You have a fifty-fifty chance — a mess or a masterpiece

Don't kiss on canvas

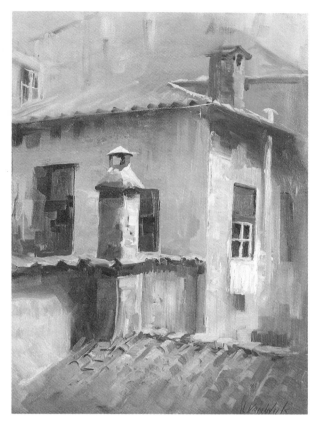 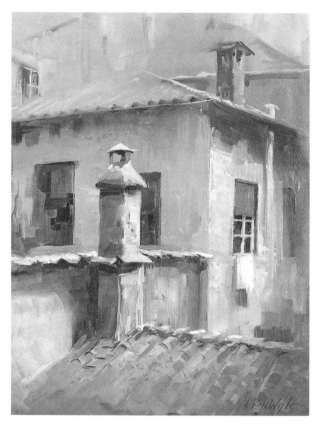

Be careful how shapes meet their surrounding areas and other shapes. Things should look like they are either in front or in back of the things they are near. This can be easily done by **never letting shapes just touch.** I call this mistake "kissing on canvas"; avoid it by making shapes overlap or moving them apart completely. In the painting on the left, see how one of the windows seems to "sit" on the wall and the other one looks attached to the chimney. The wash hanging out of the window seems attached to the wall and the shade attached to the window. The painting on the right shows you how much better the painting is without kisses, especially around the chimney.

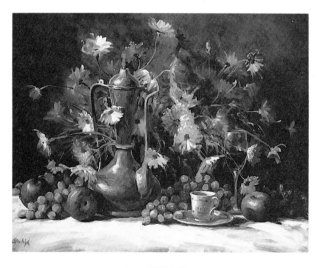 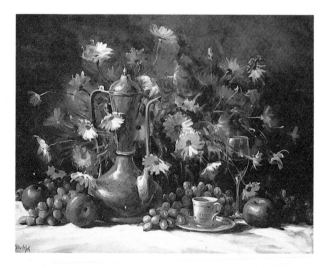

It's easy to create "kisses" in flower paintings where blossoms, leaves, pot and other still life objects are composed in such close proximity to one another. On the left, the flowers just touch the pot: top of the spout, two on the lid, one on the handle. The grapes just touch everywhere. The flowers just touch the glass and the grapes and the fruit. The glass sits on the saucer. Many of the stems are going along the edges of the flowers. Compare this comedy of confusion to the painting on the right. See how much more dimension as well as sensibility it has. Avoiding kisses, it will make a world of difference in your paintings.

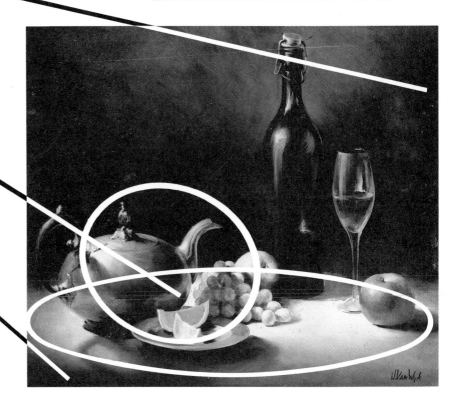

Since the **focal point** is the most important element of composition, you should know how to make one. We can always go to nature for the solutions to pictorial problems. We have a tendency to look where the light is going so the impact of your lighting can establish a focal point or area. Notice how the table is illuminated by the light from the left. The circled area is **the focal point and is where the light is imposing its greatest impact.** Your **interest** in a subject, your **choice of a subject,** your choice of a **light on it,** its placement on a canvas (never in the middle), balanced by its surroundings, unified by your **technique,** made interesting by a variety **of sizes and shapes,** all are the considerations your composition needs to be successful.

In the four diagrams below, the heavy lines represent the impact of the lighting and where the focal areas would be. The other, thinner lines point out the supporting areas of the composition.

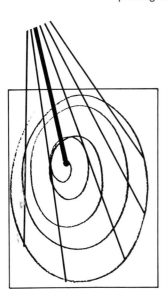
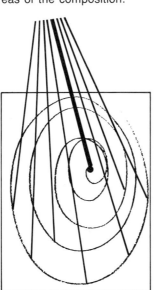
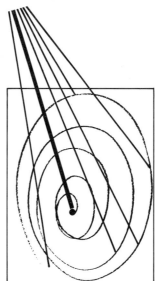
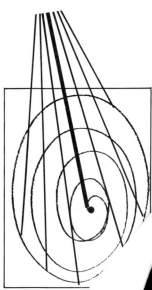

74

It's not what you paint

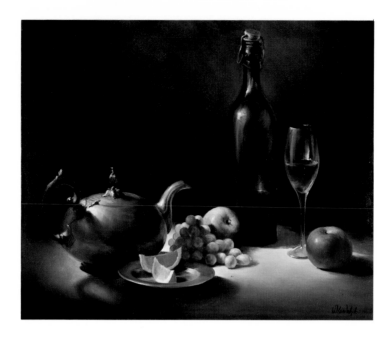

I love to paint still life. To me, it's not painting things; it's painting a mood and a presentation of an arrangement. My painting, "Teapot Glow," has subjects in it that I've painted before but its mood and arrangement are unique. Each still life records a new or renewed interest or inspiration. The little green Chinese figure is part of a setting, part of an oriental mood. **Don't paint things; paint compositions.**

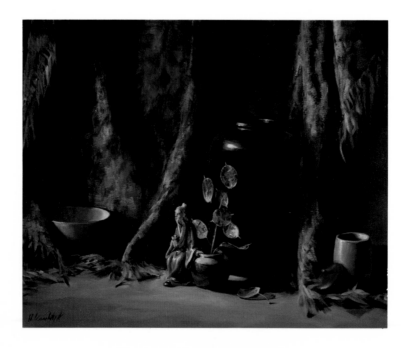

It's how you paint it

14.
Part of a model's likeness

Painting hair

Students who want to become portrait painters seem to worry about skin color, likeness and the model's expression. Much of their concern should be directed to how influential a model's *hair* is to his likeness.

The student also has to learn how to paint this rather complicated texture. From a technical point of view, painting hair is far more difficult than painting skin. Chapter 5 (*Reflections in Water....*) explains a technique that, oddly enough, can be used in painting the texture of hair.

Painting hair is an example of a basic brushing technique. The painting process is always the same, only the subject changes. True, each subject presents its own pitfalls which have to be overcome by some forethought and analysis.

This chapter has to do with how the hair's silhouette against the background and against the face should be of utmost concern, and how important the highlight is to make the hair shine. These are the areas of work that will record hair beautifully and make the hair contribute to a model's likeness.

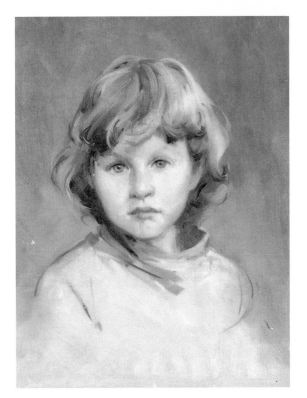

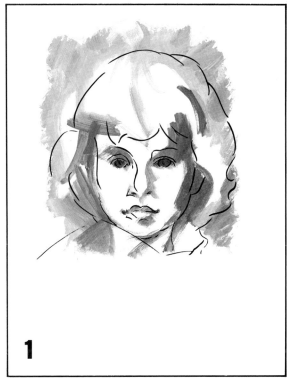

1

Hair frames the face

Painting the texture of hair is only one part of the problem of recording a model's hair. How it meets the background and how it surrounds the face are, in fact, the more difficult parts of painting hair successfully. **These two diagrams show you how you may overcome these problem areas.** 1. Shows how the background has been painted into the silhouette of her head. This will enable stroking the hair color out over the background, making it look tousled. 2. Shows the edge of her face all blended. It represents the work involved in moving the flesh color out into the hair area so the tones of the hair can reshape the face and be painted over her forehead. **A beautiful, final effect always needs preliminary work.**

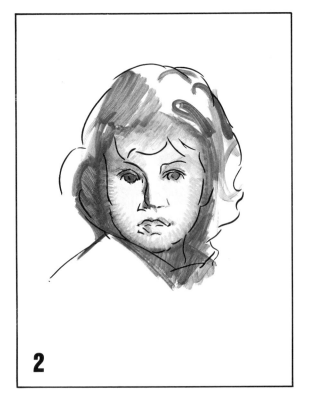

2

The found-and-lost factor that describes an outline is most noticeable where hair meets background. It can best be done by starting a stroke that represents hair within the hair shape and moving the stroke out and over the background by pulling this stroke away from the canvas as it encounters the background. A lost, or fuzzy, edge that so describes the "fall" of the hair will happen.

The first thing you see is the last thing you do

The way Brittany's hair fell in front of her face inspired me to paint her picture. What an involvement! I had to paint her little face first before stroking her hair in front of it. See how the cast shadow from her hair on her face contributes to the realistic appearance of my inspiration. I painted the outer silhouette of her hair as it encountered the background and her body only after I had painted the background and her body. Before painting hair you must prepare the area so your strokes can "comb out" over and into wet paint. Doing so stops the pasted-on look.

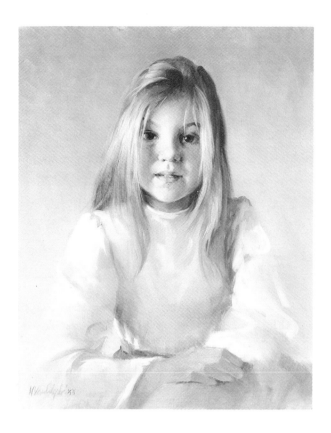

Take time to put your models at ease by telling them about your painting procedure. I ask them to have their hair the way they like it to be for the first sitting even though I won't get to paint the hair on the first sitting. I need to see its effect on the face and be inspired by the model's general appearance. Then I tell the model when I'll need her hair to look right again, usually after I have done the background and almost finished the face.

Combing hair with strokes and color

The colored diagram shows where complementary color is used to paint hair. Anna's blonde hair was massed in tones of yellow: White, Yellow Ochre and Burnt Sienna. The complementary violet (black, white and Alizarin Crimson) added to the hair color was used to paint in the shadows. These shadows were later darkened with accents of Burnt Umber. The shine (or highlight) on her hair was also complementary, made of white and Alizarin Crimson applied to a lightened hair color of white, Yellow Ochre and some Cadmium Yellow Light.

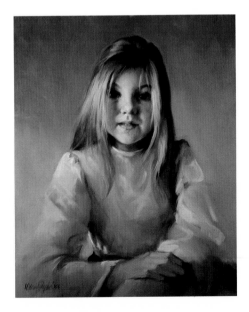
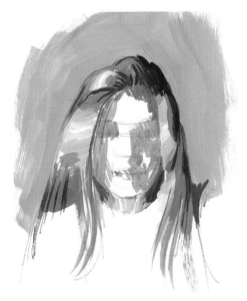

The diagram shows how I painted Brittany's hair in strokes that were opposite from the way that it's combed. By doing so, I could "comb" these colors together with brushstrokes.

The periphery of your pet's shape should be done the same way that I showed you on Brittany and Anna's pictures, the difference being that you comb the hair out in shorter strokes depending on your pet's fur. The hair texture of fur can be painted by putting all the tones in opposite from the way it grows, saving the final effect to be accomplished by feathering the paint with a soft, dry brush.

Reigning cats and dogs

Color mixtures for all types of hair

Hair, its color and the way light affects it is a good way to examine color and come to some simple, logical conclusions about color mixing. All hair color is a form of yellow, from tow-haired to silver gray, from ash blonde to black. Where light strikes, all hair colors are warmed. Where light doesn't strike, all hair colors are cooled. Color reacts as we do to the sun: we're warmed by it and cooled by the shade. The color yellow has the broadest range of tone and intensity. It can be light and bright — like a lemon or blonde hair — or dark and dull: The color of mahogany or brunette hair. Yellow can be pale and light—like sand—or dark and seemingly black—the way we think of ebony. All these colors I've mentioned are forms of yellows. The shadows on all these colors are complementary to yellow and are made by the addition of a tone of violet. The shine of these colors is also made with violet in a very light tone. Shadows are always accented with darker versions of the mass tone color.

On our palettes, we have many yellows: The Cadmiums, the earth colors, such as Yellow Ochre, Burnt Umber, Raw Umber, Raw Sienna. These colors can be further extended with additions of white to lighten, and additions of black and white to mute. These colors can be tinged with reds for the redder versions of yellow hair, such as carrottops and Titian-colored tresses. Now for some general color mixtures:

Hair Color	Body Tone	Body Shadow	Dark accents	Highlights
Blond	White, Yellow Ochre	Alizarin Crimson, Thalo Blue, added to Raw Sienna, Burnt Umber and white	Burnt Umber, Thalo Yellow Green	Alizarin Crimson, white
Light Brown	White, Yellow Ochre, Burnt Sienna	Alizarin Crimson and black added to body tone	Burnt Umber and Burnt Sienna	White, touch of black and Alizarin Crimson
Dark Brown	White, Burnt Sienna, Burnt Umber	Burnt Umber, Burnt Sienna, a touch of Thalo Blue	Burnt Umber, Thalo Blue	Alizarin Crimson, Thalo Blue, and white
Red	Burnt Sienna, Cadmium Orange, white	Burnt Sienna, a touch of Thalo Blue	Burnt Sienna, Burnt Umber	White and Thalo Blue
Gray	Black, white, Yellow Ochre	Black, white, Burnt Umber, Thalo Blue	Black, white, Burnt Umber	Black, white, Alizarin Crimson
Black	Touch of white, black, Burnt Umber, Alizarin Crimson	Thalo Blue, Alizarin Crimson, Burnt Umber	Alizarin Crimson, Thalo Green	Black, white Thalo Blue

15. Drawing and painting

They are not the same

The remark, "I can't paint because I can't draw a straight line," is a common one. It leads one to think that drawing and painting are the same. But this conclusion couldn't be more wrong. An accurate statement, to dispel the above, is, "You draw a drawing and paint a painting." Why? A drawing is made of lines with a marking type of instrument. Paint was meant to cover a surface by using a spreader-type of instrument — a brush. By moving a painted area against a contrasting painted area, a so-called line appears. Painting, therefore, is a matter of making edges rather than lines. In painting, these edges have much variety: from very sharp to very fused in appearance. The brush can also fill in large or semi-large areas of canvas. How unlike drawing with a pencil!

Small brushes are so often used by the beginner in painting because he thinks they are similar to a pencil, feeling he has to make a line with it. This still comes from the misconception that drawing and painting are the same. I *can* see how people are confused because both actions — drawing and painting — make shapes and the principles of getting correct shapes have to be adhered to by both the "drawer" and the painter. By realizing that they arrive at shapes in two different manners, you will remove the fear that you don't draw well enough to paint.

This chapter will help you think like a painter instead of a drawer, and you will learn how to use your drawing ability within the framework of the painting process. Actually, drawing is a constant consideration in that you are always trying to make shapes from the beginning stages of painting to the final touches. By the way, putting in those final touches is the time to use your little brushes.

After studying this chapter, you'll never have the problem of drawing your whole picture in and then ruining it by painting it. This technique will show you how a subject's beautiful shape will come as a result of your painting.

From the top down

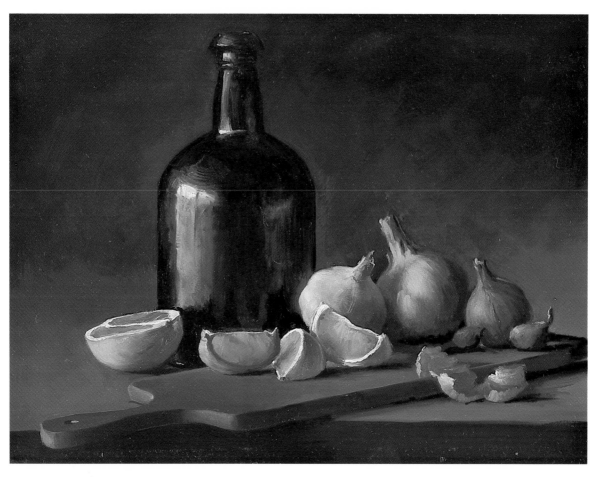

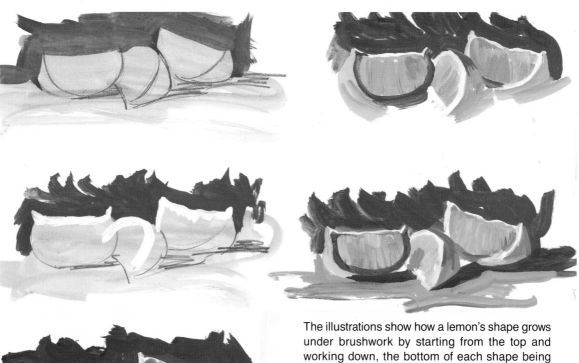

The illustrations show how a lemon's shape grows under brushwork by starting from the top and working down, the bottom of each shape being corrected by the top of the one under it.

Overlappage

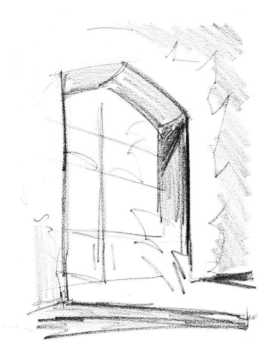

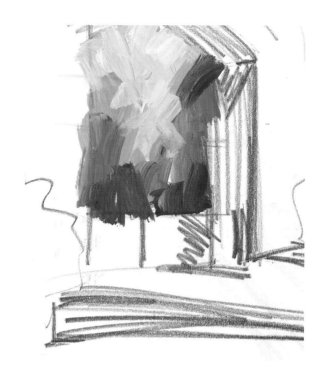

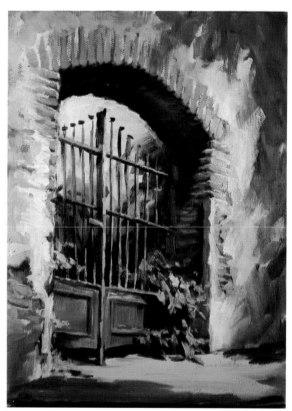

When I paint landscapes, I employ the technique of "overlappage" so I can control the shapes of the elements of my composition. This overlappage can be also done as you paint in many small strokes (a la the Impressionists). The brushwork can suggest an atmospheric quality to the painted surface. This painting was done from a photograph I took of an old gate in Verona, Italy, on one of our visits. Painting from your own photographs guarantees originality. Working from photographs that were taken by others should be so designated.

Finding the found-and-lost line

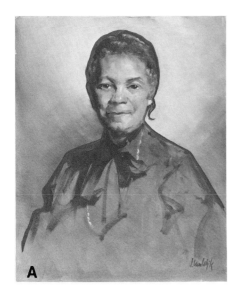

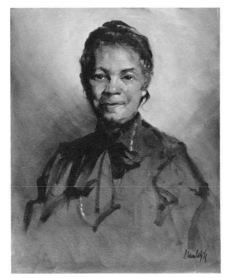

The way outlines look and the way you paint them also contribute to a dimensional effect. See how flat the sharp periphery on illustration "A" looks compared to the portrait.

A

The overlapping technique can put you in control of so-called outlines. A beautiful edge evolves by moving the tone of the subject out into the background tone. Notice the difference between "B" and the painting where the dog's anatomy is so much more defined by employing **found-and-lost edges.**

B

This is a subtle example of the found-and-lost — **or fuzzy and sharp** — edges. Sharp delineation makes planes project; fuzzy ones make planes recede. "C" makes the monk look posterlike compared to the painting.

C

16.
Drapery as subject and background

Difficult but not different

H ave you ever heard a painting of drapery described as "looking like a bunch of hanging sausages"? I hope this chapter will teach you how to make drapery look like beautiful folds instead. Oddly enough, sausages and folds are the same anatomy, that of cylinders.

A beautiful rendition of folds is very much a matter of arranging them with a variety of shapes and with respect to how they function for pictorial effect.

I'd like to direct your attention to Chapter 13, *The Focal Point.* You will see why drapery and the way that it is arranged usually has to serve the focal point because drapery is often a background. When it doesn't perform that function, drapery has to serve the form that it's draped over. It's when drapery is painted with ignorance of its role in the picture that it is accused of looking like sausages.

This chapter will not only show you how to construct folds or drapery, but will also help you to deal with them artistically.

Arrange your basic cylinders artistically

Oddly enough, this painting with two cylinders (crocks) points out the important factor that you need to realize when painting drapery. See how one crock casts a shadow on the other. See four tone values on the larger crock: **The highlight, body tone, body shadow and reflection.** See how these **same tone values** appear on the folds in the painting, "Bashful Maiden." All the folds were painted with those same four values and cast shadows were added to the areas shadowed by folds.

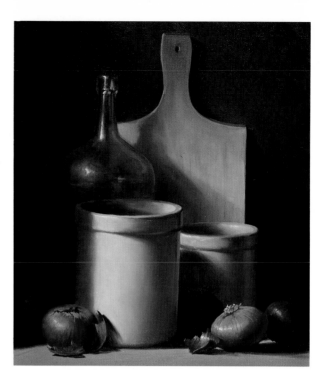

Unfolding the mystery of folds

Folds are basically cylinders

Paint drapery by first painting in all the shadows: The body shadows and cast shadows alike. Then mass in the color of the body tone, to the body tone add highlights, to the body shadow add reflections and darken the tone of the cast shadows.

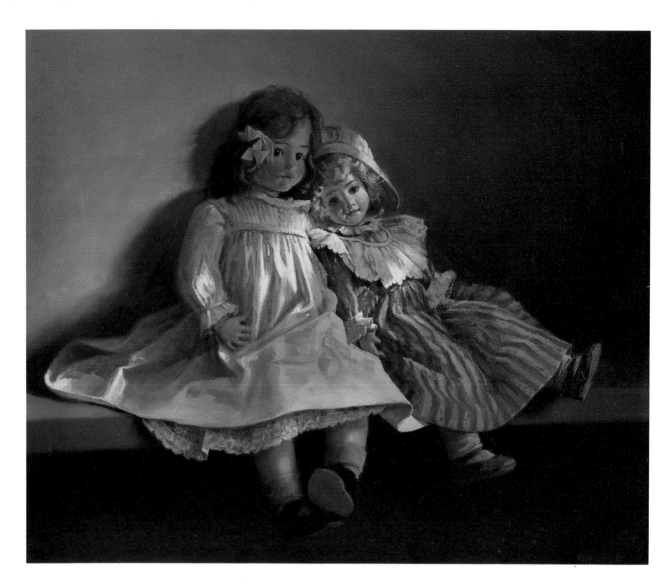

Practice
Practice
Practice

Practice studies are very important. It would be terrible not to know how to paint drapery when you're faced with subjects such as dollies and even more so when your little model wants to be painted in her party dress. Don't just paint pictures; **paint practice pictures.** They sometimes turn out pretty well.

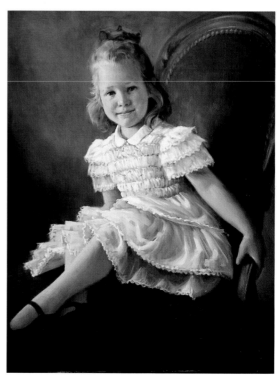

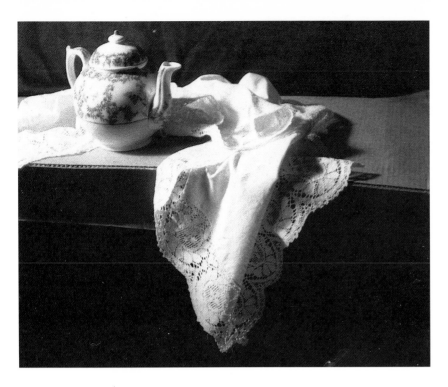

A reliable, simple practical procedure works for all things, even drapery

Here's a step-by-step recreation of how I painted a teapot and a lace-draped runner to help you realize how a basic, reliable procedure works for even more complicated subject matter. Pictured is the set-up and a diagram of how I indicated the placement of it on the canvas. This stage is always my initial **must.**

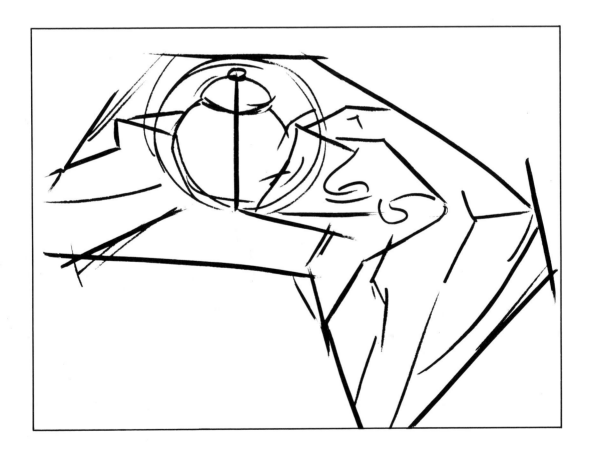

Look for the tones of the colors

1

Another must is to search out the simple pattern of light and dark of the entire composition. Don't single out the pot and the drape; **see and paint the entire arrangement.** I always do this stage in values of black and white and more often use acrylic (black and white) to do so.

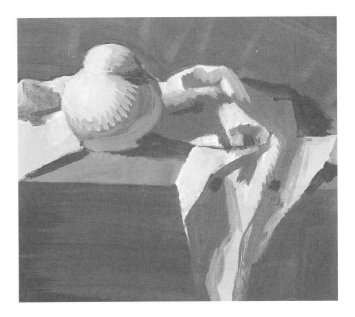

2

Then I repaint all the areas in color, being able to concentrate on the way the tones blend together since I no longer have to worry about the overall composition.

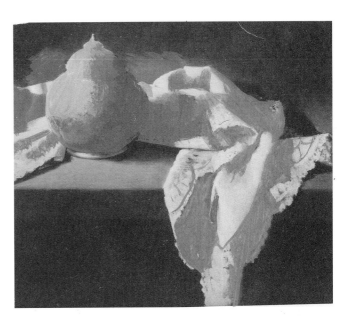

3

Having done Stage 2 in darker, more muted versions of the subject's real appearance, I zero in on my subject's dimension and texture by adding lighter tones to the light areas and dark accents in the shadows and finally adding reflections in the shadows, too.

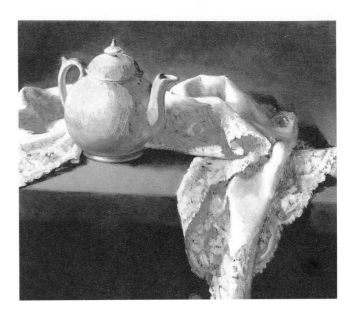

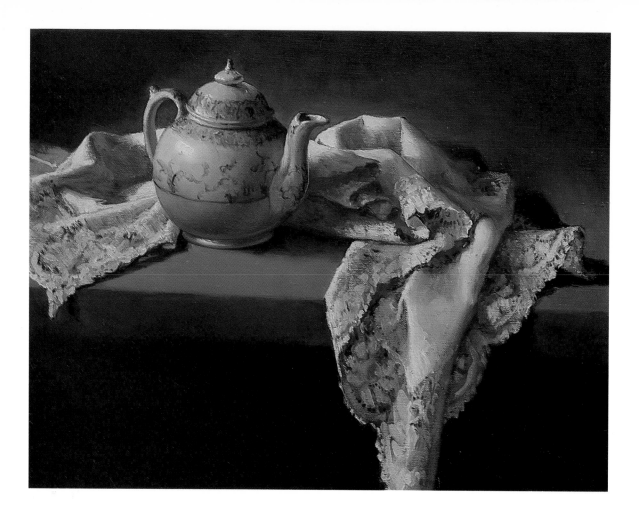

Mix it, judge it, adjust it

Here are the color mixtures, as best as I could give them, for painting **Teapot and Lace Runner.** I mix color the way many cooks cook: A bit of this, a bit of that, tasting as I go. A cooking recipe can give you proportions of the ingredients, but I can't give foolproof recipes. The mixtures for this painting can only guide you. You have to adjust them as you work to achieve an artistic adaptation.

Teapot mass tone: Mixture of white, a touch of black, Burnt Umber, Burnt Sienna and Yellow Ochre.

Teapot body shadow: Touch of black, Thalo Blue, Alizarin Crimson, mixed into body tone color.

Repainting of body tone in a lighter value: White, Yellow Ochre, Burnt Sienna, further lightened with white, and Burnt Umber.

The highlight: Alizarin Crimson and white.

In the shadow area: A mixture of black, white, Burnt Sienna and Burnt Umber.

The reflection in the shadow: Black, white, Burnt Umber and Thalo Blue.

When the pot was dry, very thin Thalo Blue was used for the decorative pattern.

The lace runner: Painted with the same colors as the teapot but with less of the warm colors into the gray mixtures.

I must stress that color mixing is made easier by being tone-value-aware. In forty-five years of teaching, I've never had a student who had difficulty with color. Almost all of them, however, have had trouble in recognizing the tones of colors.

17.
How to paint white things

A valuable color lesson

White flowers, white clouds, white vases, white collars and blouses are just a few of the many white objects that you will be called upon to paint over the course of your career as a painter. If you do not treat white as a color, you will never be able to record white things beautifully.

Many adjectives are used to describe white: *Bone* white, *pure* white, *blue* white, not to mention the very popular catchall — *off* white. And these descriptions are true; every white object has its own peculiar white coloration. By hard boiling an egg, its color and texture become subtly different from those of a raw one.

An artist has to train his eye to look for the subtleties; using white subjects is a wonderful training ground for this development.

Now that we know there are several versions of white, we also must realize that these white objects have to be influenced by lighting in order to see and paint them. It is more the light on white subjects that you have to look for and paint. Not that you don't do the same when painting more colorful subjects. In fact, when painting white objects, you will be painting the colors that light causes; when painting colored objects, you only paint the light's *influence* on its color. So, oddly enough, painting a study of white becomes a valuable lesson in color.

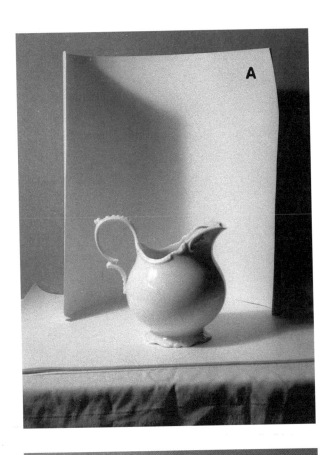

Light white and dark white

So many students wonder how to paint the color white and how to paint it against white. Oddly enough, they never worry about painting red against red. Painting **red against red** is just painting two different tones of red — which seems so obvious. Why, then, can't this be applied to painting **white against white?** I know why. People don't think of tones of white: Light whites and dark whites yet they can realize light blues and dark blues. To paint a white pot against a white background, we have to arrange the tones of the background so we see a darkened white against the light side of the vase. Notice how this effectively shows the shape of the pitcher in **A** compared to the flat, light, white background in **B** . To darken your background on the side of the canvas where the light comes from is the most effective way to show off the atmosphere and dimension that your subject is in. By doing so, you are wrapping the background around your subject just as the piece of paper that I've used as background is arced around the pitcher. I know you will not see this contrast behind your subjects, but your background is not just what you see; it's a chance for you to **create a beautiful setting for your subject.**

Complements: Nature's color formula

Here's a photograph of the still life arrangement that I used for the painting shown on page 95. Compare them and see where I've made tonal adjustments. The most effective one is in the background where the left corner is dark.

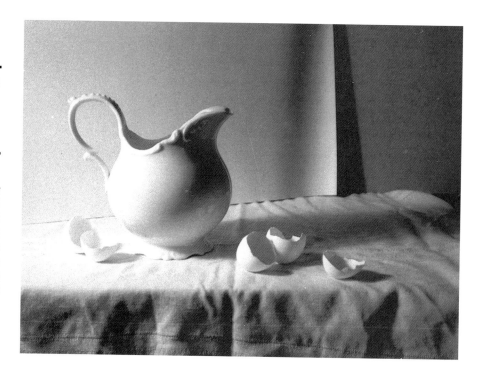

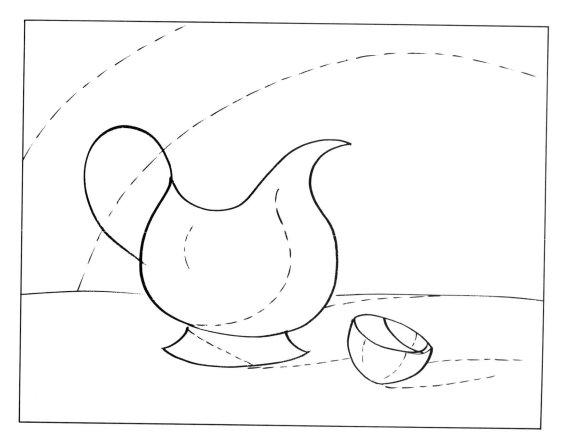

This strange-looking diagram is **the most important color-mixing lesson in this book.** The dotted lines show where the complementary color, violet, has been used in painting the yellowish white pitcher, the yellowish white eggshells, the yellowish white background and table. The complementary color of any color is always used in these places: The edges of shadows and in highlights.

Use lots of color to paint the color white

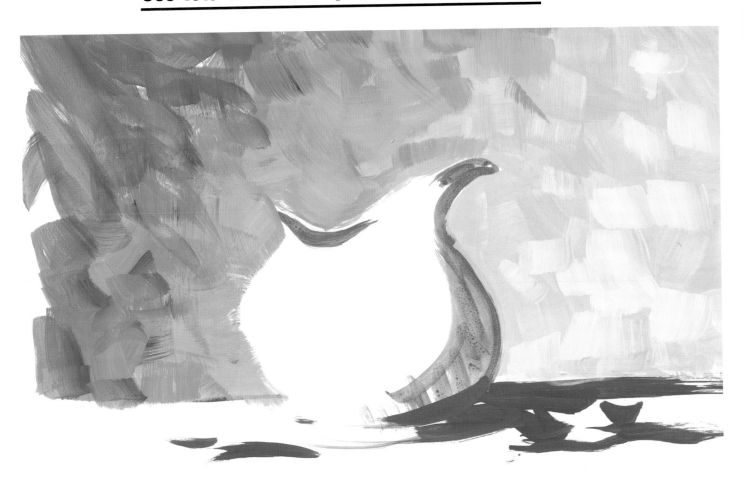

These diagrams show you the actual colors I used to arrive at the painting that appears on page 95. The biggest mistake students make in painting white, or any color, is not using enough color. It's better to start with lots of color. It will stand up under the pressure of blending and modeling.

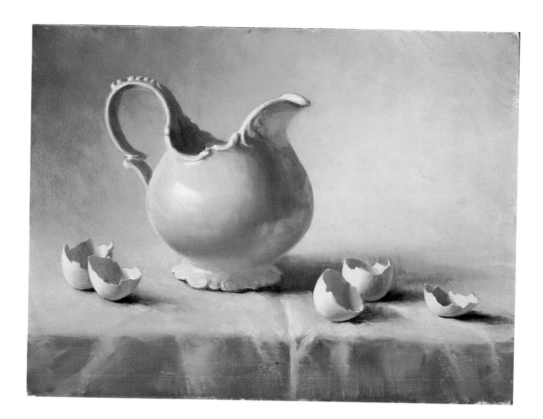

Go to Nature to find color's secret

The color mixtures for this pitcher are cooler versions (less Yellow Ochre and Burnt Sienna) of the same mixtures for the teapot on page 90. This same coloration was used to paint the eggs, the background and table. The use of a color in combination with its complement is not my invention, as many of my fans think; it's an analyzation of nature's light. That's why my paintings of colored things—white or any other color—look natural. **You can't mess around with Mother Nature.**

I have been fascinated with painting white for years and every time I used white subjects in a class, my fascination was revitalized. I've enjoyed indulging in a love for a subject. Another subject that inspired me for quite a time was light shining in a window into an interior. White subjects made me focus on color; interiors made me respect perspective. Inspiration comes from experience. Teaching inspired many of my white compositions; sunlight, my interiors. I always have still life to fall back on when the urge to paint hits.

The ons and offs of white

Painting white subjects is a wonderful lesson. It's a chance to see the colorful effect that lighting imparts. If you can paint a white subject correctly in tone and color, you'll be able to paint all other colors correctly by using the same color theory that's so obvious on white.

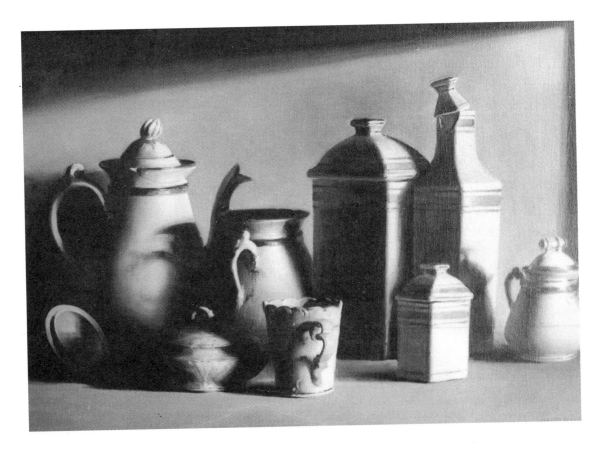

18.
The technique of the old masters

Glazing

Our knowledge of the techniques of the Old Masters is somewhat speculative. Much of what I teach about these techniques results from conclusions that I've drawn from my many years of study and experience. There are, however, certain things we do know about the Old Masters: They must have worked efficiently because their output was prolific; they must have used their materials economically since they didn't have the advantage of squeezing color out of tubes (as we know them) or art stores stocked to the rafters with materials supplied by a multitude of manufacturers. I have often said to my students and lecture audiences, "The Old Masters had so little and did so much..." and left it at that.

Now to the technique of the Masters. Many people don't realize that oil paint is transparent. To understand transparency, let's compare oil paint with watercolor which we *know* is transparent and which is used transparently. You know, of course, that the watercolorist does not use any white paint, relying instead on the whiteness of his paper and how much his color has been diluted with water to regulate the color's lightness and darkness.

Oil paints are made with the same pigment as watercolor except that they're mixed with oil (the binder for watercolor is gum arabic). Nevertheless, oil colors are just as transparent. The use of white paint makes oil colors opaque. This is where the techniques of the oil painter and the watercolorist differ, and why painting with oil paint is referred to as *working opaquely*.

If oil color, without any addition of white, is thinned with a painting medium (such as linseed oil) and applied on a toned surface, it will color that tone without covering it. This fact is the clue to the Old Masters' economic use of color. They seemed to have applied most of the tones of their compositions first with a fast-drying medium (tempera) in a monochrome — which is called an underpainting — and then colored these tones with transparent applications of oil color which are called glazes. This process not only was practical but it gave them the opportunity to put great artistic thought into the two major areas of picture development: composition and tone in the underpainting; color and final effects in the subsequent layers.

The appearance of the painting by the Masters of the 17th century has been described as "glowing," "luminous," "rich," "profound." From a practical point of view, the Masters knew that two coats were better than one, knowing full well that one application of oil color would not cover well. If you have had to paint a room, you've experienced that too.

This chapter will acquaint you with the technique of doing a monochromatic underpainting and how to apply glazes to achieve rich, luminous color.

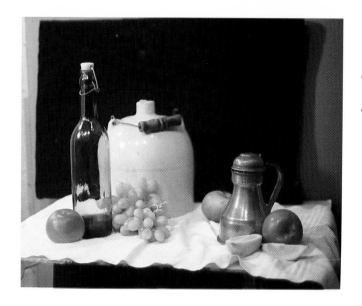

The sneaky, safe way of painting

Pictured here is the still life setup used for the painting below. The pages that follow will illustrate and explain what I know—or have concluded—about the techniques of the Old Masters. Developing a painting with this technique is called the **indirect method** (putting color over an underpainting of tone) as opposed to the direct method (mixing color into tone). This "sneaky technique" way has many advantages and is my favorite way of painting.

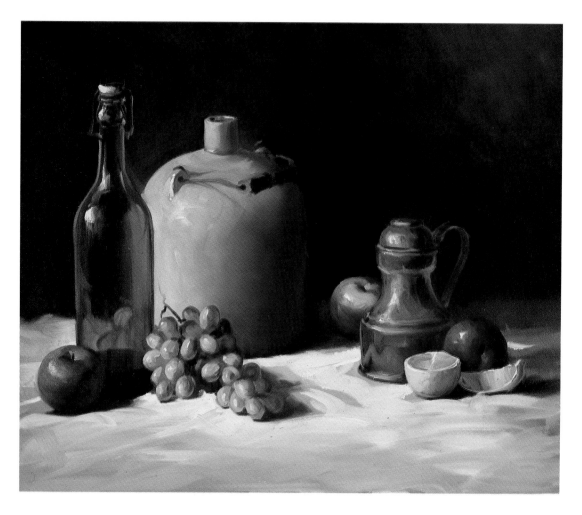

This is the painting I did for my first video instruction tape, "Oil Painting Techniques and Procedures." It demonstrates the complete painting process as well as teaches all the painting principles. There is no more to learn to be a better painter. Instead, you must appreciate fully the profoundness of the basics of painting.

Every picture starts the same way

Even though I use the same reliable procedure to start all my pictures, it's never boring or ever repetitious. It begins a new experience, a new composition, something that has never been done before. This, along with the wonderment of how it's going to turn out, makes beginnings a fascinating time.

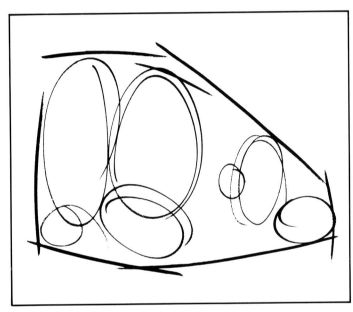

1 This illustrates how the four marks (top, bottom, two sides) have helped me proportion the arrangement to the size of the canvas. Within these four marks I see how I can make everything fit by relegating and recording the shapes as ovals.

2 Now I've put down some lines to suggest the actual structure — or anatomy — of my subjects. Just as this demonstration is going to show you how to sneak up on color, may I suggest you sneak up on drawing, too, by indicating proportions first and then developing that proportion's shape.

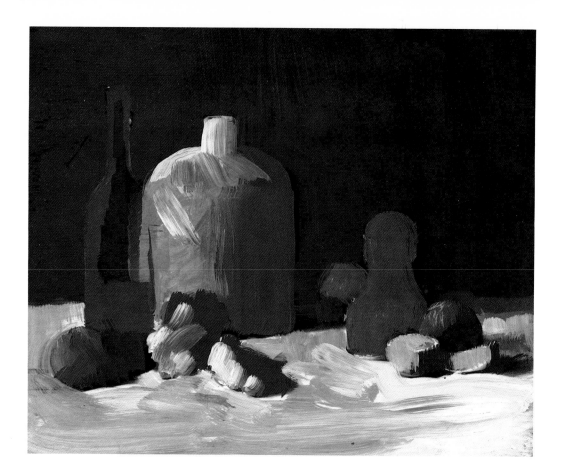

The start of an underpainting

The two steps you've just seen have guided me to this stage. Shown here are all the objects, dressed in their basic tones. Surely not in color nor finished-looking but recognizable. This is the beginning of the **underpainting** which I do with mixtures of **black and white acrylic paint.** I use acrylic paint for underpainting because it is fast drying. An underpainting must be **absolutely dry** before the color stage can begin — which will be done with oil paint. I assume that the Old Masters did their underpaintings with egg tempera. Acrylic paint, I believe, is the 20th century's version of tempera, the oldest painting medium known. You have no doubt heard that you can't mix oil and acrylic together, or paint acrylic over oil. I heartily agree with these two warnings. I disagree with the admonition that you can't paint oil over acrylic. I've been applying oil paint over acrylic underpaintings for more than twenty-five years with no disastrous results.

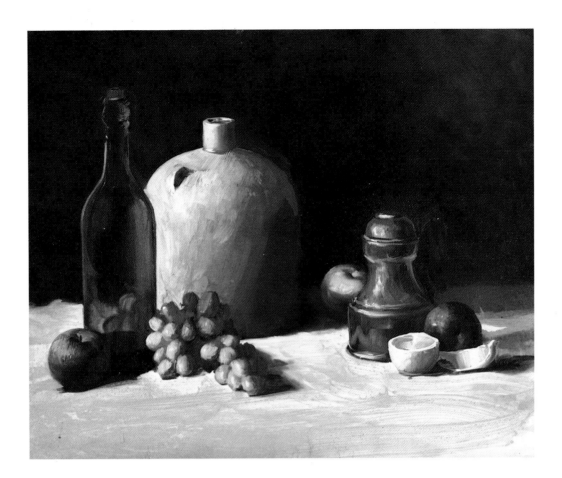

The finished underpainting

Now, still working with acrylics, I have added more contrasts—lighter and darker tones—to the underpainting. See how this has further developed the appearance of the subjects. This is the kind of underpainting that **can be developed in color by glazing** with color. Even when I want to work in the direct method, I do an underpainting, more like the one on the previous page. I hardly ever start in color — direct or indirect — without a tonal rendering of my composition. Whether I'm doing an underpainting for direct application or one for glazes, I make sure that the acrylic is applied thinly enough to maintain the texture of canvas. Any thick buildup of acrylic would impair the adherance of my oil paint to the underpainting. The importance, and rendering, of an underpainting have always been difficult to teach. A common complaint is, ''why do I have to do it all in tones and then cover it in color?'' The **advantages of an underpainting are many** and, I guess, only recognized by the more experienced student who has learned the limitations of the capability of oil paint. An underpainting's advantages are:

1. It establishes the composition.
2. Its tones are the foundations of recording the basic colors correctly with glazes that are more luminous than opaque mixtures.
3. It allows you to work in safer, more controllable thin applications. These three advantages accomplish so much that I can't understand why students question them.

Glazing the picture

A glaze is an application of transparent color (no white). It is thinned with a painting medium (Grumbacher Oil Painting Medium II). For faint color, lots of medium; for more robust color, use just enough medium to spread the color. In either case, the glaze should **color** the underpainting **not cover it.** The glazes impart an overall richness of color. Since the application of glazes isn't thick, it can withstand the brushwork of additional colored accents. Compare its glazed stage to the finished picture on page 98.

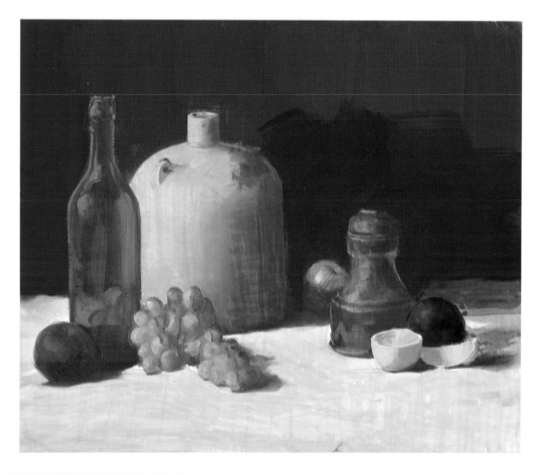

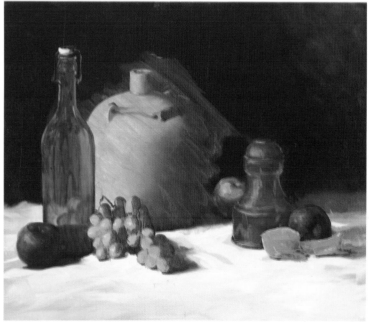

The diagram on the left shows the glazing stage in progress. Raw Sienna has been applied to the jug, Sap Green to the bottle, Burnt Sienna to the copper, Grumbacher Red and Alizarin Crimson to the apples and Thalo Green to the grapes.

19.
A special kind of realism

Trompe l'oeil

A painting that looks realistic is one that records the subject in dimension. The viewer marvels that on a mere flat surface he sees depth and feels as though he could walk into the picture.

Trompe l'oeil is a French term that means "deception of the eye" and describes a special kind of dimension on a flat surface, not one of depth but that of projected dimension in that subjects seem to leap off the flat surface.

This phenomenon is not so much a matter of an unusual painting prowess but that of arranging subjects in such a way as to present the illusion.

To do a *trompe l'oeil* type of composition, you must assume that the canvas surface is the background plane and the subject is in front of it. Making the subject look as though it's in front and sticking out beyond the canvas plane is due mostly to a cast shadow from the object onto the background. So, in practicality, this chapter focuses on the importance of the cast shadow as well as introducing you to the intrigue of painting a *trompe l'oeil*-type of still life.

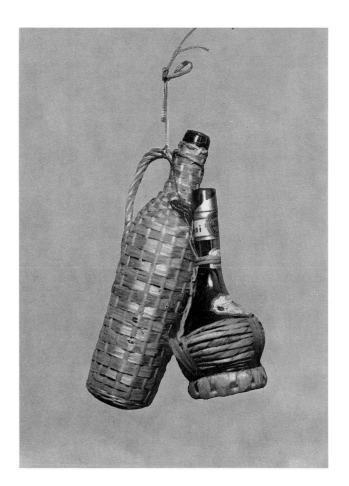

Never work from a flash photo

Never work from a photo taken with a flash because the lighting flashes from **your** view, causing a flat lighting on your subject.

Always see cast shadows

Only when there is a cast shadow visible from a subject (top right) do you have the contrast necessary to render a subject realistically. An example of a typical **trompe l'oeil** is a subject hanging on a wall.

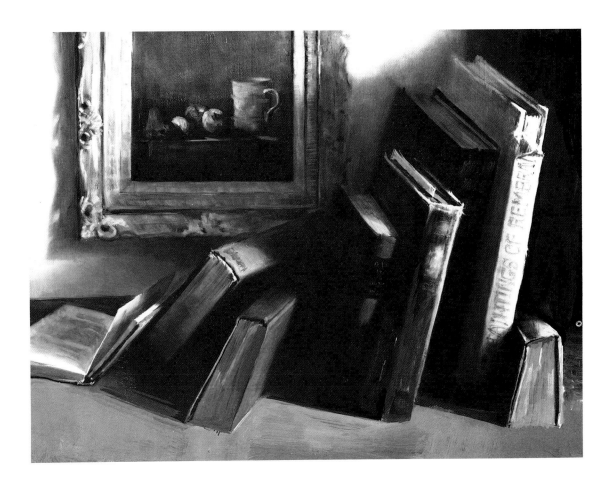

The table's edge

A **trompe l'oeil** aspect of a painting is always one of things jutting out at the viewer. Things look as though they're going to fall off the canvas. This effect is achieved mostly by arranging subjects and then by an accurate rendering of the cast shadows from them. See how the addition of a table's edge (pictured below) had made the books jump out. I've seen fantastic examples of **trompe l'oeil** in the palaces of Italy. Especially beautiful and amazing to behold is the decoration at the Borghese Gallery, the walls of which have been painted to simulate columns, statues and different types of marble panels and molding.

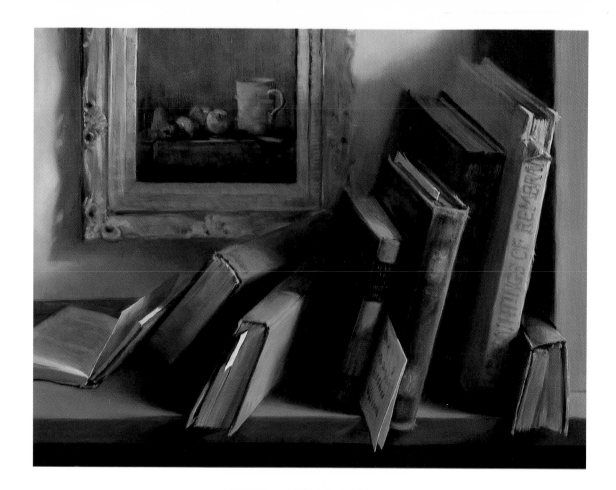

Pictorial theme

My fascination with **trompe l'oeil** inspired this picture. I relied on repeating a basic shape in many views for pictorial unity and theme. The rectangular painting jumps off the background; the rectangular books, seen in perspective, stick out beyond the shelf. I think pictures should have a theme; it gives them punch.

Pictorial impact

In **Old Ballerina Slippers,** I used an unusual lighting effect to add pictorial impact. I arranged to have light just strike here and there, as though it were coming through a window to add an air of mystery instead of painting them in full light.

20.
A portrait sketch

Alla prima style

Most of the chapters in this book zero in on a particular facet of either procedure, technique or a painting principle. When faced with a model and the desire to capture his essence on canvas, all the elements of technique and procedure and a clear understanding of the principles have to be at your fingertips.

The very definition of a portrait sketch is that it looks as if it's been done easily. We look at sketches and are not aware of the model's hours of patience and the artist's many hours of work mainly because they're done in a relatively short period of time.

Everyone has a pace; some people work quickly, some slowly, so the time that the painter uses to do a portrait sketch depends on his pace. Don't compare yourself with someone else. Painting is very personal and never more evident than the challenge of doing a portrait sketch. This is apparent even before you touch that canvas with a brush; it starts with how your model acts on the model stand.

I, personally, try to put my model at ease, and tell him not to worry about how he looks or how I'm going to make him look. I try to make him a partner in my work, making him realize that his interest in what I'm doing should be as important as mine. My model's interested cooperation fortifies me in what I'm doing. His curiosity as to what I'm doing to him would be distracting. A portrait sketch of a good model usually takes me about two hours. If my model insists on worrying about the end result, I start to do the same. If the painting is a failure, I feel justified in blaming the model.

Lou: From start to finish

Pictured here is Lou Polack. Notice the light coming from the left, causing an interesting shadow pattern on the right side of the face that describes his features and facial expression. Below is my reliable "**ready-get-set**" stages.

There are certain fundamentals that can help you to keep the features in perspective. The corners of the mouth line up with the irises of the eyes, and the nostrils always line up with the pits of the eyes. **Never forget what perspective does to the appearance of your subject.**

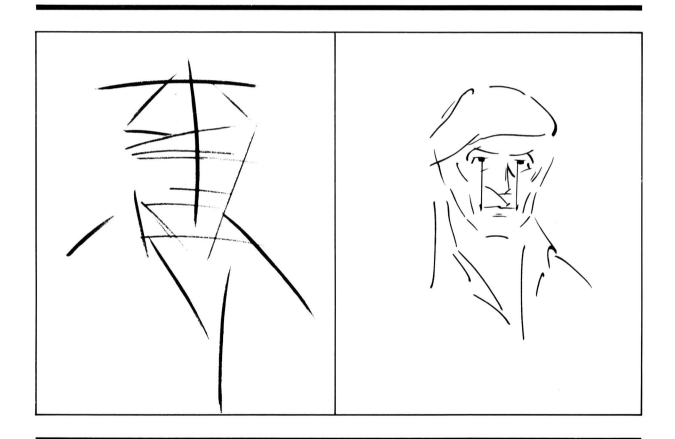

Save those accents for last

Here's a diagram of what students see when starting a portrait. These are important, descriptive shapes but should not be the beginning; they should be the last accents.

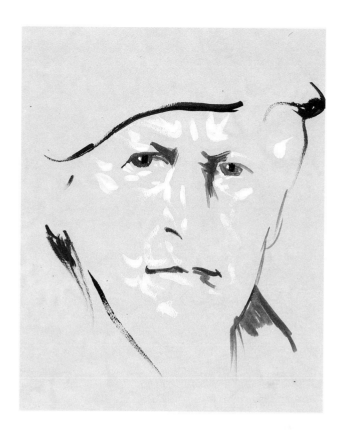

Painting the beginning stage

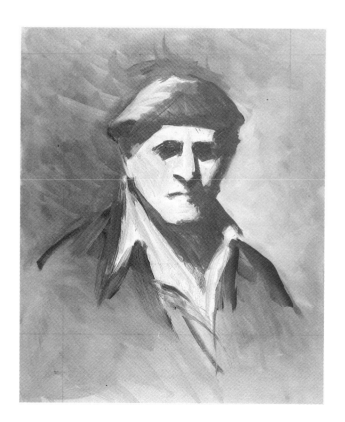

Start with the shape instead

Instead of the above, the beginning of a portrait should be this: A bold lay-in of the shape of the light on the face, the shape of the dark pattern and the tones to indicate the background and body. Do this with turpentine-thinned tones of black and white. Don't use Burnt Umber; gray is better than brown. Good beginnings should look like a good portrait might evolve. You and your paint are not omnipotent enough to get a human likeness in one fell swoop.

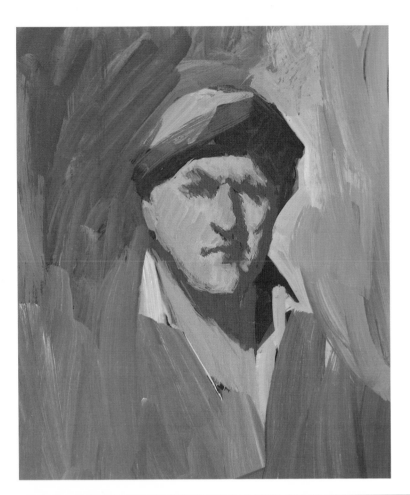

Flesh color

Now's the time to paint the **notorious flesh color,** which is only seen where light strikes the face. This is **the clue to mixing good flesh colors.** White paint represents light and so, all flesh-type colors (yellows, oranges, reds) have to be mixed into your white paint. Lou happens to have a very red complexion. In this case, especially, you can see how inappropriate it would be for me to give you his flesh color as a formula for everyone you want to paint. I can tell you that this initial lay-in of your model's flesh colors should be substantial in that it covers the canvas well and is a hardy version of your model's complexion.

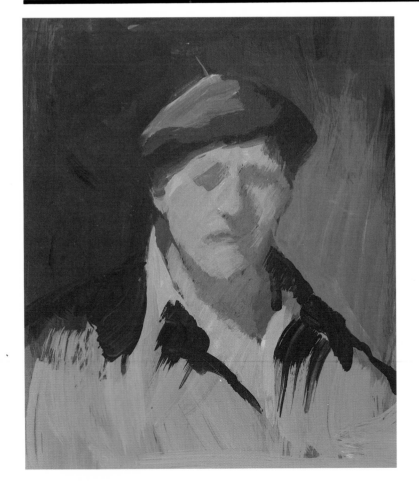

Shadow color

Now the painting has been further developed by using a gray-green (made of black, white and Sap Green — a complement to the reddish complexion) for the shadows on the face, and blending them where they meet the flesh color. See how this has softened the contrast and makes it seem as though **I'm losing Louie.** Many students think that the blended, smooth look is at the end when, actually, blending is part of every stage, especially this one.

The modeling stage

The flesh color shape and the shadow color shape have been repainted, and **now I have Louie back.** This is the modeling stage; it's the time to carefully observe and paint the features on the face. At this stage of the picture, I also paint in the background so that I can paint in the model's outer shape.

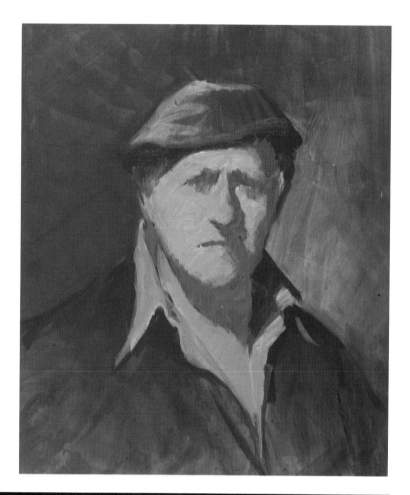

Save the goodies for last

The finished painting. By comparing this to the stage above, you can see that I have added lighter accents of tone to the already light area. These light tones are shapes of highlights that I saw on the concave and convex planes on Lou's face. Some darker tones of flesh colors, made by putting warm colors into gray, added definition of the features in the shadows. The diagram on page 109 shows you the highlight pattern and the dark accents. I paint in last what students begin with.

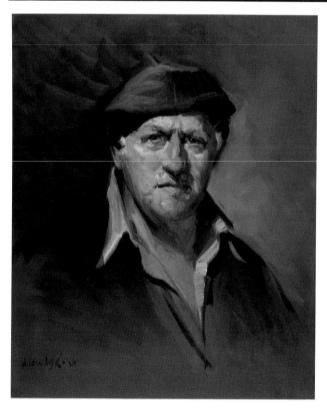

Time makes a difference

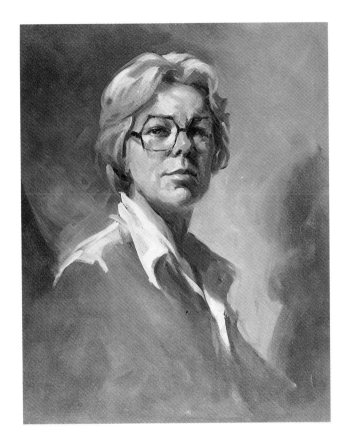

Students tell me about their worries. They worry about a likeness; they worry about mediums; they worry about how long their picture is going to last; they worry about whether they have any talent; but they never worry about a very important factor — TIME! I **know** they don't worry about this because they think they have all the time in the world and, as a result, often **never** finish their pictures. The amount of time used to paint a picture contributes greatly to a part of a picture's appearance and charm. This is noticeable in portraits. The two paintings shown here surely prove my point. My self portrait looks as though it was done quickly compared to the one of Patty. I always take the element of time into consideration, because with each picture my aspiration of how I **want the paint to look,** makes me have to judge how much time this look is going to take. Then I organize my painting time accordingly. A student often asks, "How did you get that carefree, loosely painted look?" My answer: "I was in a hurry." Surely, the hair in Patty's portrait wasn't done in a hurried way. Since a painting records an artist's painting experience, it provokes its viewers to ask: "How long did it take you to do that self portrait?" And my answer: "Two hours and forty years."

21.
Rhythm of application

Weaving baskets with paint

Baskets are a wonderful example of learning brushwork or, what I call, *rhythm of application.* The action of a brush loaded with tone and color can suggest many subjects. Surely, the many leaves on a tree suggest a way of moving your brush; a picket fence can be suggested by a brush action; and we've seen in Chapter 14 how stroking paint can record hair. In painting, brushstrokes are undeniable and come as a result of your appreciation of the look of your subject in terms of paint.

So often an entire texture can assume a look of reality by painting one area in sharp focus and just suggesting its entirety with a rhythm of application, a kind of guilt by association.

Form first, texture later

Before becoming involved with the weave of a basket, you have to paint the form of the basket. Do so by using two tones — light and dark, as seen in stage 2. The light should not be as light as you see on a basket and the dark not as dark as you see on a basket; this will allow you to add the **weave with stronger contrasts.** Count the number of vertical stays and paint them with a dark tone. Notice how they get closer together as they near the edges of the basket due to perspective. Now, with a lighter basket color, paint across those vertical lines to suggest the weave. Basic basket mixtures: Yellow Ochre, Raw Sienna, Burnt Sienna into white for the basic body tone. Darken this mixture by adding some more Burnt Sienna and Burnt Umber, plus black and Alizarin Crimson for shadowed basket color. "Weave" with Yellow Ochre and white.

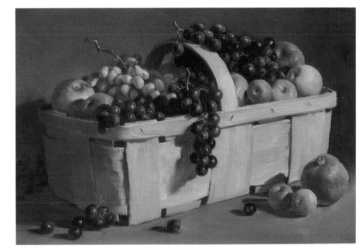

Baskets vary in shape and weave

There are many different types of basket weaves; examine them carefully before interpreting them with paint. Understanding your subjects fortifies the observation you need to paint them. Notice in the basket of grapes, the weave of the basket is just suggested. The sewing basket is more carefully painted to coincide with the more carefully painted spools of thread. The basket in the fruit painting was fun to do, once I figured out which band went over and which went under.

The artist's world is brushstrokes: skies, trees, fruit, fields, lace, and so on...

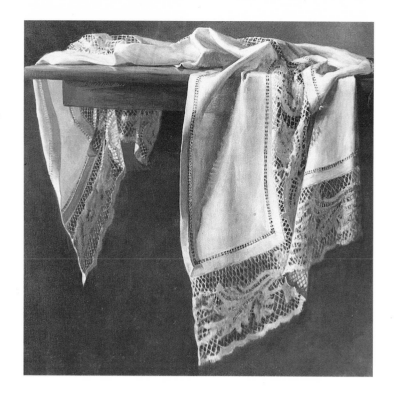

All actual things have to be translated into brushstrokes of paint done at the most convenient time. Brushstrokes can't be denied and so, make the best of them. Lighter tones, greatly thinned, added the lacework to the cloth. First the larger design and then the little connecting threads. Of course, over a dark, dry area. The colored embroidery threads were sewn on with fine colored lines.

22.
Relying on the basics

Practical progressions

Some wise teacher once said: "Start with a broom and end with a needle." This statement proposes that a painting should be started by seeing the subject simply, leaving all details and refinements for the final stages. It's a basic, practical procedure of application.

Before even starting with that big brush, a painter should have figured out a practical approach to his particular subject. All the basic principles have to be adjusted for the job at hand. These two analyses of painting are ever-present no matter what the subject. You can't find a simpler formula. In fact, you shouldn't look for a formula; each picture should be a new challenge. The painting process remains the same but it's your attitude about each new challenge that will add the stamp of originality to all your paintings.

Let's see how basic procedures have to be adjusted to paint various subjects and to obtain interesting effects.

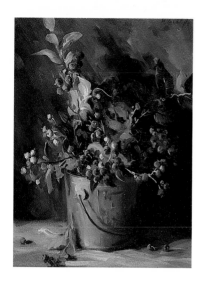

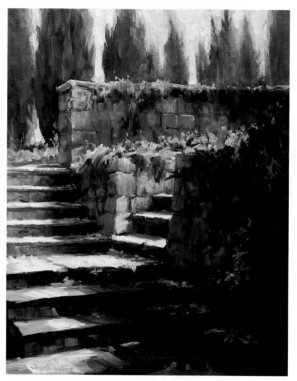

Each picture a new planning challenge

The Apples. The more fragile green color was painted in big areas and was cut down by red, the stronger color.

Blueberries. The bright, light blue color on the blueberries were added last.

Italian Street. Realizing a vanishing point at the left helped me put the houses and street in perspective.

Steps of Ricavo. I painted the sunlight on the steps with a palette knife to keep the color clean and make the paint emulate the texture of stone.

Being artistically practical

Our Room in Ricavo. The sun striking the shiny marble floor fascinated me. First I painted the reflections of the room in **downstrokes,** then I added the shine in **across-strokes,** and popped the sunlight in last with clean, thick Cadmium Yellow Medium and white.

Tuscan Vase was painted without its pattern, left to dry and then the **pattern was glazed on.** Notice how the stems of the pears were also saved for last.

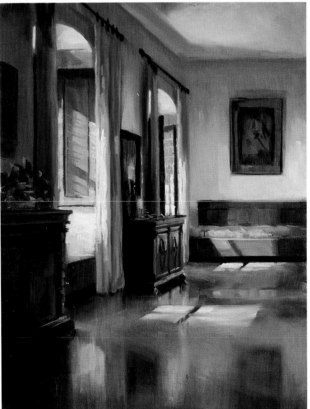

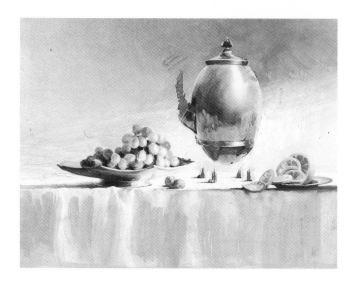

Paint what you need to get what you want

All beginners are greedy little monsters: They want the final results right away. It's like eating dessert first. These illustrations show the working stage which makes the finishing stage so pleasant and substantial. **The background on the silver teapot picture took hours, as most backgrounds do.**

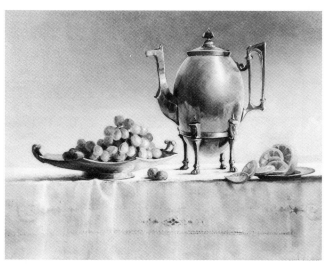

I made the linen cutwork tablecloth look like it was just material on a table and hanging down from the table before I dragged over it with a big brush just tinged with a lighter tone to make the material look like the texture of linen. Then I cut out the cutwork with darks and embroidered around the holes with lighter and darker tones of paint applied in little stitch-like strokes.

23. The three basic paint applications

Glazing, scumbling, direct

O il paint is really quite versatile. It can be applied in many ways. It's up to the painter to decide what effect he wants and how he can get it. Understanding the three basic ways of applying paint will give great scope to your painting effects.

These applications are: glazing, scumbling-and-dragging, and direct (*alla prima*). Alla prima, the workhorse to technique and the most popular method of painting in use today, is often referred to as "wet-in-wet." It is applying tone and color in coverage somewhat all at once in progression from thin paint to thick paint.

Dragging-and-scumbling is an application that can effect any painted area. It is an opaque mixture (meaning it has white in it) and usually imparts a light tone, such as mist, fog or rain. *Glazing* is a transparent application that's always applied to an absolutely dry area; it always adds color. It's used to darken and enrich the color of areas. It's used to add patterns and decorations of color. This chapter contains some examples of these techniques.

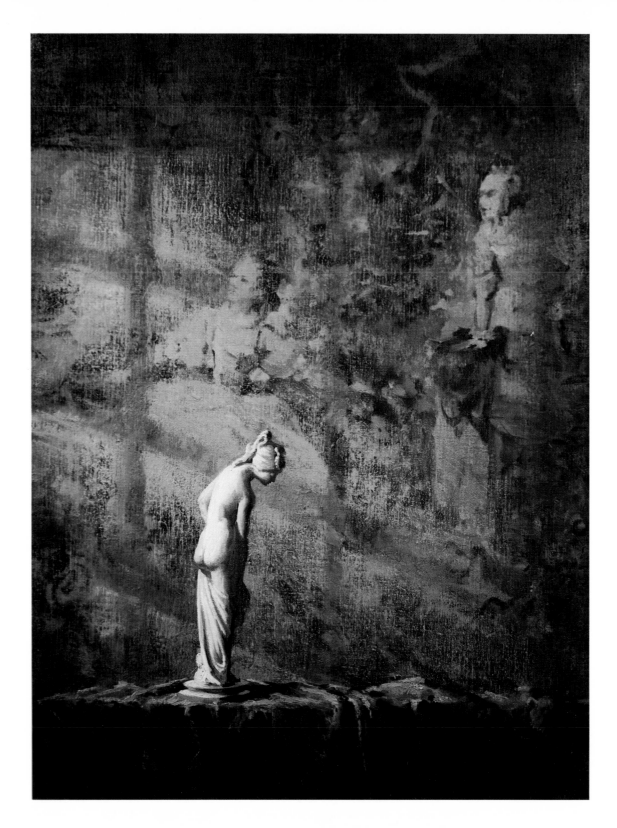

Using all four methods in one painting

The colors of the tapestry were painted **alla prima.** When they were dry, the rough texture of the tapestry was added by **scumbling** with a light tone just skimmed onto the roughness of the canvas and the painted pattern. The light streaming across the tapestry was done by **dragging** even a lighter yellowish color. The figure was painted **alla prima.** The red of the draped cloth was **glazed.**

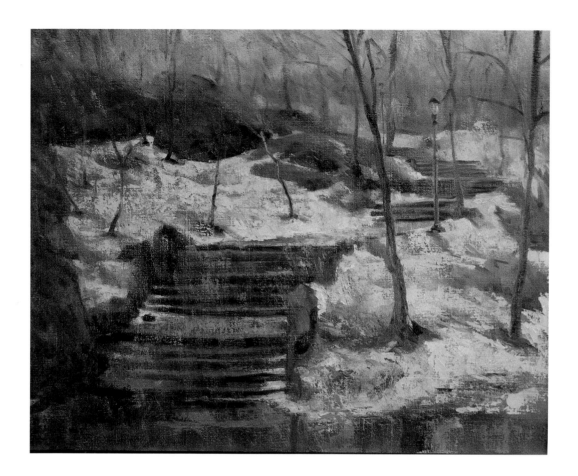

How to paint rain and sunlight

▲

The drizzly rain in the landscape above was interpreted by dragging a light gray tone over the canvas after the entire scene was painted.

◄

The various textures of the old facade (on left) were done by scumbling and dragging colors over the basic colors of the wall.

Dragging skims the surface

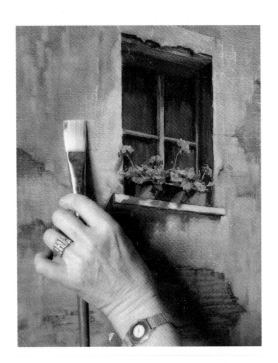 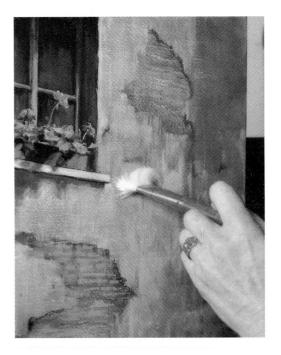

The dragging method was used to add the fringe in the painting (above). The two photos show the hand position you must assume to drag color. The color on your brush should not be wetted with medium. Load the brush with pure paint and blot it with a rag to make the dragging process successful.

24.
Beauty in the shadows

The reflection

This chapter is about *reflections*, one of the five tone values. These are not the reflections as seen in water (Chapter 5) or the reflections in glass in Chapter 9. These are the beautiful ones seen in shadows.

We've learned in the earlier chapters that we paint the effect of light all the time and the beginning of the dimension on canvas starts with a light side and dark side, referred to as the *body tone* and *body shadow*.

Chapter 12 singled out the highlight as being extremely important; Chapter 20 emphasized the importance of the body tone and body shadow, and Chapter 19 was mostly about cast shadows.

Now, let's learn about the reflection, the most subtle, most difficult tone value you will have to deal with.

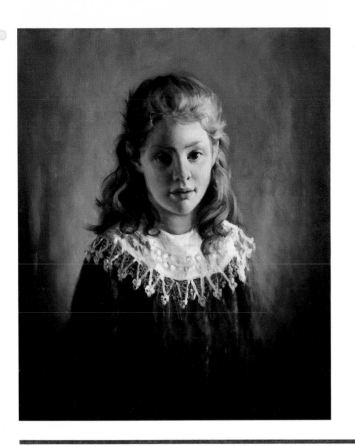

Be careful about reflections

The correct tone value of the reflection is one of the most difficult ones to see. It's a lighter tone in a shadow, and imparts great beauty to it. **Its attraction makes students paint the reflection too light.** By doing so, the depth dimension of the shadow is lost, the composition is impaired and the painting begins to look "schmaltzy." The illustrations show how the reflection in the shadow on Melissa's face would be if it were too light or missing. Without it at all, the picture loses some of its charm and with one that is **too** light, the dimension and mystery of the shadow on her face is lost.

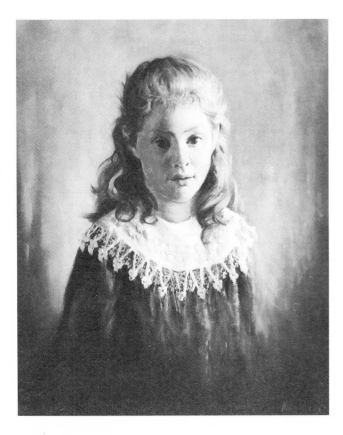

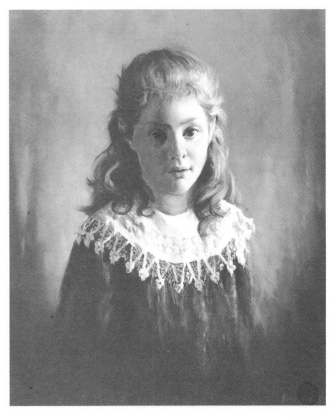

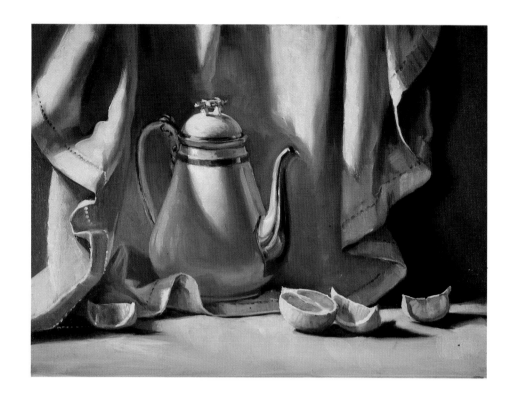

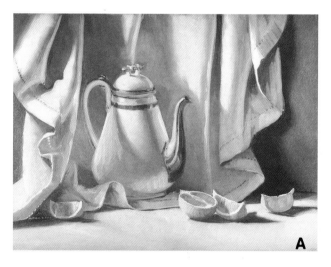

A

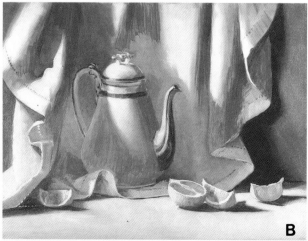

B

The last but not least tone value

In the beginning of this book, we learned the importance of the five tone values, and have examined, discussed and studied them. Since the reflection is always the last tone value you add, it's only fitting that I've discussed it in this last chapter. The reflection in the cast shadow on the pot from the drape not only completes the pot's form but adds intrigue to the shadow. The reflections in the shadows of the folds help them look round. In **A** the reflections are too light making the drapes look like a bunch of lines. In **B** we see that a complete absence of reflections causes an inadequate dimensional effect.

Closing remarks

Helen Van Wyk's books

Now that you have read my book, I feel that we are friends and have painting as a common interest. Whether you've just started to paint or are in the life-long battle to paint better, you might be interested in my other books. Here, then, is a listing and description of these books that could supplement this one.

Successful Color Mixtures. Easy-to-follow color mixing instructions written in "cookbook recipe" style. Instructions for mixing the color of 120 different subjects in portraiture, still life, florals and landscape. Complete color analysis. 200 pages, 8½ x 11, 72 black-and-white illustrations.

Painting Flowers the Van Wyk Way. Concise instruction on the more advanced oil painting techniques, using flowers as the main theme of pictorial expression. 120 pages, 8 x 11, 136 illustrations, 22 pages in full color.

Portraits in Oil the Van Wyk Way. 44 full-color illustrations are designed to help you with color mixing of skin, hair, backgrounds and the complexities of blending and mixing the shadows and tones of flesh.

Basic Oil Painting the Van Wyk Way. An oil painting classic! 134 pages with 52 illustrations which explain the properties of color, the colors of a basic palette and the many procedures an artist can use to paint people, places and things.

Your Painting Questions Answered from A to Z. Forty years of questions asked of Helen Van Wyk during her career as a teacher of painting. Dictionary format, 200 pages, 106 illustrations.

Helen Van Wyk's video tapes

Oil Painting Techniques and Procedures. Two hours of close-up instruction from the placement of the composition to the finishing touches. VHS or Beta.

Painting Flowers Alla Prima. One hour of direct painting with daisies as the subject. Stunning closeups put you on the end of the artist's brush. VHS or Beta.

The Portrait: Step by Step. In one hour's time, the artist finishes a portrait in oil. Brilliant photography and masterful commentary by artist Van Wyk. VHS or Beta.